SURFING SAN ONOFRE TO POINT DUME
1936-1942
PHOTOGRAPHS BY DON JAMES

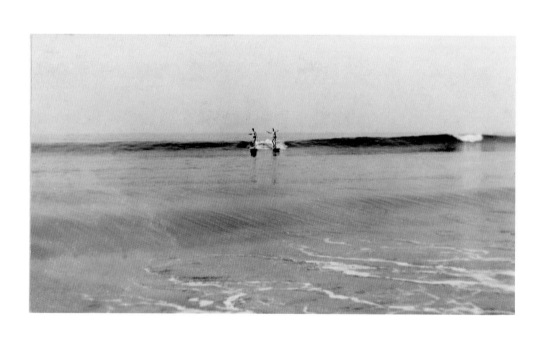

SURFING SAN ONOFRE TO POINT DUME
1936-1942
PHOTOGRAPHS BY DON JAMES

Originally published by T. Adler Books, Santa Barbara

CHRONICLE BOOKS

SAN FRANCISCO

FIRST PRINTED DECEMBER 1996. T. ADLER BOOKS, SANTA BARBARA.

(ORIGINAL TITLE: 1936-1942 SAN ONOFRE TO POINT DUME)

FIRST TRADE EDITION 1998, CHRONICLE BOOKS, SAN FRANCISCO.

PRINTED IN SINGAPORE.

LIBRARY OF CONGRESS CATALOGING-IN-PUBLICATION DATA:

JAMES, DONALD H.

SURFING SAN ONOFRE TO POINT DUME, 1936-1942 / PHOTOGRAPHS BY DON JAMES.

P. CM.

ISBN 0-8118-2110-2 (HARDCOVER)

I. SURFING—CALIFORNIA—PICTORIAL WORKS. 2. SURFERS—PICTORIAL WORKS. 3. SURFER PHOTOGRAPHY.

I. TITLE.

GV840.SBJ36 1998

797.3'2'09794—DC21 97-44788

CIP

DISTRIBUTED IN CANADA BY RAINCOAST BOOKS

8680 CAMBIE STREET

VANCOUVER, BC V6P 6M9

10 9 8 7 6 5 4 3 2 1

CHRONICLE BOOKS

85 SECOND STREET

SAN FRANCISCO, CA 94105

WEB SITE: WWW.CHRONBOOKS.COM

FOR ALEXIS, LUKE AND AUDREY

FOREWORD

1936 TO 1942. Six years of exuberance. Hometown boy Don James is witness to, and participates in, the halcyon inception of California beach culture. His faded snapshots are the definitive body of evidence of a transitory Southern California in the years before World War II changed the region forever.

In the early twentieth century, the West Coast was derided by eastern tastemakers for its hopelessly parochial attitudes and frontier mores; and within the state, San Francisco was definitely the capital of California culture. Prewar Los Angeles was a dusty, brawling camp placed in the middle of a road to nowhere. The population of the city in the 1920s was just over a half million, and this grew to 1,504,277 by 1940. Don James's Los Angeles bore no resemblance to the sprawling metropolitan monolith that today is home to in excess of nine million persons. Route 66 terminated at the end of Olympic Boulevard, near the Santa Monica pier; from there the Pacific ocean stretched to the horizon. The eighty or so miles of rugged coastline between San Onofre, some seventy miles to the south, near San Clemente, and Point Dume, a shorter distance to the north, just beyond Malibu, were reachable only by winding roads traveled by the few who knew the pleasures of an empty beach and perfect blue breaks. For these six years, Don James and his friends called this stretch of land their own. They lived and thrived on a lifestyle that had never existed before.

For recreation, James and crew ventured down miles of bad road to the no man's land of San Onofre, or surfed the clean, wild coves of Rancho Malibu. Just a few years previously, they had seen the end of landowner May

8

Knight Rindge's valiant effort to keep the state and federal government off her 17,000-acre chunk of prime coastal land at Rancho Malibu. Her legions of lawyers and armed cowboys finally succumbed to the pressure of the developers who, in 1929, opened the concrete ribbon of the Roosevelt Highway (now called the Pacific Coast Highway) that cut across her land. The road brought in the public, and finally, nearly four hundred years after the Portuguese explorer Cabrillo first set eyes on this stretch of coastline, the secret was out.

SURFING'S ARRIVAL

Surfing came to California by way of Hawaii. Wave-riding had been a pastime in the islands for two thousand years, but the onslaught of colonial development—and its attendant social mores—wiped it out. By 1900, surfing was virtually extinct in Hawaii, though isolated pockets of locals continued to ride ocean swells to the great displeasure of the missionaries. Then, in 1908, Alexander Hume Ford founded the Outrigger Canoe Club at Waikiki to promote traditional Hawaiian sports such as canoe racing and surfing. Gradually the sport began to reemerge. In 1931, George Freeth, the "Bronzed Mercury" immortalized by author Jack London in his essay on surfing, was lured to the mainland by local developers eager to populate the empty Los Angeles beaches. Freeth's surf-riding exhibitions in Santa Monica Bay drew record crowds, enticing new converts to the Hawaiian sport of kings.

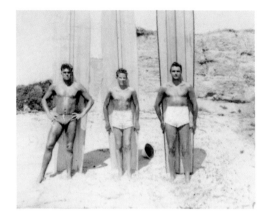

In 1920, there were perhaps two hundred surfers in Hawaii and California. Most of the mainland riders were directly inspired by Freeth's brief stay, but they were left largely to their own devices following his untimely death. They made it up as they went along, crafting ninety-pound red-wood boards that cut through waves without the help of fins, fiberglass, or foil design.

Today surfing is a $1.35 billion industry that annually churns out 375,000 surfboards and 535,000 wetsuits

for sale in 3,600 specialty stores. It is estimated that some four million Americans have surfed at some point in their life, and surfing is being groomed for a slot in the 2000 Olympic Games in Australia. But large corporate numbers and such highly organized athletic events bear no relation to the seminal photographic documents in this book, because from 1936 to 1942 surfing was still purely about the experience—the burn in your shoulders from carrying your ninety-pound plank two miles down the perilous cliffside trail to the cove; the sensation of skimming down the face of a chilly breaking wave at sunrise, with a gentle offshore Santa Ana wind delivering the scent of distant orange groves.

These devices allowed any individual to document everyday life; and with no commercial expectations or potential media exposure to cloud matters, Don James recorded only what he felt was interesting. His resultant images, made between the ages of sixteen and twenty-two, are highly personal depictions of a group of his friends who lived extemporaneously as they pioneered activities that were absolutely indecipherable to the greater culture at large.

James remembered, "In the 1930s, the concept of riding a wave while standing on a plank was completely alien to everyone. There were little groups of people who surfed, but they didn't necessarily know of one another. Altogether there were probably less than a couple of hundred guys in the entire state. The photos were a way to let people know what we were up to. We were involved in this great activity and totally stoked up. I guess there was also a little ego gratification involved. It was a good deal to display them and impress a pretty girl. At our high school, we were the only kids like us; everyone else played football.

THE CAMERA

The widespread dispersal of Kodak Brownie and folding pocket snapshot cameras and the development of the 16 mm Cine Kodak home-movie camera in 1923 coincided perfectly with the emergence of this sport and lifestyle.

"When I saw Tom Blake's surfing photos in National Geographic that was it. We'd go to the library and pore over Blake's stuff. My dad had an old Kodak folding camera, and I grabbed it and started taking photos. Our group hung out at the Del Mar Club in Santa Monica, and we worshipped the older guys like Bob Butts, Bob Moore, Pete Peterson, Paul Stater, Chauncy Grandstrom, and Johnny McMahon. We were the only teenagers around. I began shooting pictures to show our parents and teachers what was going on. You know, 'Hey mom, look, it's not so bad, it's actually neat!'"

The range of James's accomplishments and the dramatic sweep of his life impart the impression of a glorious rags-to-riches fable. This might have been the scenario: The barefoot boy triumphs over Depression-era poverty, saves scared flatlanders from the ominous ocean, performs adeptly in motion pictures, survives combat in World War II, and becomes an international sports figure and prosperous celebrity dentist who settles into the seductive sun, surf, sand, and sex of Camelot-by-the-Sea.

The unglossed reality is no less dramatic. "Life in the Depression was hard, but it encouraged us to appreciate what we had and to live simple lives. My dad scrambled to keep us afloat. It was never too bad for me because there was always the beach to turn to." Don recounted tales of catching reef fish and pulling huge abalone and twenty-pound lobsters from the sea that were then boiled over beach fires. He and his friends would raid orange groves for all the fruit they could eat. Extra money was pooled into a gasoline fund so that they could make the several-hour drive to the most distant and pristine beaches. For the worst dirt roads, Don and his friends strapped four old tires to the roof of the car in preparation for multiple blow-outs.

HEROES

Like some of his mentors, Don became a lifeguard at a time when lifeguards were generally unrecognized and went unrewarded for their heroism. There was no lifesaving

profession to speak of, and those who dedicated their lives to ocean centricity were viewed with contempt, or at best with heavy suspicion, by society at large. Guards were seasonal volunteers, and their economic status was so precarious that some of Don's friends resorted to living in the closed-down lifeguard station illegally during the winter months. Though they could avoid paying any rent, they also gave up such luxuries as heat, running water, electricity, and indoor toilets.

Years before, these lifeguards helped the authorities dredge the bottom of Lick Pier in search of missing evangelist Sister Aimee Semple McPherson, while the sensationalistic popular press fueled the fires of pious despair. They plucked the "floaters" who had become wedged in the State Beach reef and stood on "suicide watch" at the municipal wharf because of the brigades of "wanna end it all" jumpers who came out in full force after the bars closed. When Lifeguard James came of age, he saw it all, photographing the activities of the Santa Monica crew as they invented many of the standards and practices in use by surf lifesavers around the world today.

The people depicted in these snapshots constitute a colorful cast of Runyonesque characters. Ten years earlier, rum runners had come ashore at Paradise Cove during Prohibition, and organized crime bosses anchored gambling ships offshore from the Santa Monica Pier in order to be beyond federal and state jurisdictional limits. The secluded coves and inlets and offshore islands of the region still beckon aspiring denizens of the illegal import trade, and a wide variety of law enforcement agencies regularly maintain a presence. In Don's time, many of the locals who knew both the lay of the land and the nuances of the sea always found lucrative employment functioning as guides, facilitators, and transporters in this underground economy.

A decade before, during Prohibition, many a beach boy profited by delivering surf-splashed Canadian whiskey to the appreciative stars who congregated along Santa Monica's golden coast. Times were hard, and these resourceful native sons adapted with distinction. The enterprising surf fishermen filled orders for copious amounts of lobster, crab, and fish for top restaurants, studio parties, and society dinners. If the hard work of

pulling a living from the sea proved too taxing, there were other avenues of support.

Golden boys seldom went hungry in this land of illusion, where looking good was a form of currency in itself. Some began careers in the cinema industry as actors, camera operators, grips, stunt men, and extras. Olympic swimming champions Duke Kahanamoku, Buster Crabbe, Johnny Weissmuller, and Jackie Coogan all frequented the area's beaches. These surfing actors connected many of their beach friends with the filmmakers for walk-on parts and day wages.

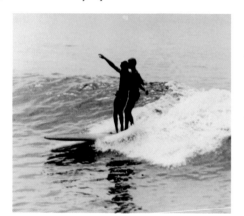

HOLLYWOOD-BY-THE-SEA

The seemingly separate worlds of Hollywood and surfing interfaced in other, more intimate, ways. World champion paddler and Santa Monica lifeguard Tom Zahn was pursued by Marilyn Monroe during his stint as a Twentieth Century Fox contract player. Gary Cooper's wife, Rocky, not only convinced her actor husband to take up the sport of surfing, she also took lessons from one of Malibu's premiere sportsmen. Later, aspiring actors from the surf lineup like Peter Lawford squired comely studio dates like Lana Turner. Joel McRea was promised a part in a picture by David O. Selznick if the young actor could teach the movie mogul to ride a surfboard. Selznick never mastered the art of *he'e nalu*, but McRea got the lead in the film *Bird of Paradise* anyway. The production is best remembered for Joel's scandalous nude midnight underwater swims with Delores Del Rio and for its slack key and steel guitar–based score, which became the prototype for innumerable South Seas soundtracks.

As a boy, Don James remembered paddling his board three miles offshore to visit the movie ship *Bounty*, which had a stellar crew including Charles Laughton and Clark Gable. Don was employed by the posh Bel Air Bay Club, where an afternoon might be passed helping astrophysicist George Ellery Hale learn the finer points of body surfing, or assisting novelist Raymond Chandler as he evacuated the bar after a few too many.

Later on, Don's heroic and cinematic mien landed him a gig doubling for Cary Grant in *Mister Lucky*, and roles in films like *Back to Bataan* and *The Moon is Blue*. He discounted any infatuation with the workings of the entertainment industry, however. "I don't remember the names of most of those films, they were just a way to earn money. They gave you $35 to start, and with salary adjustments for stunt work, you could pocket a hundred bucks a day."

Hollywood beckoned the outside world to savor the delights of the fantasy factory in countless productions. Publicity men had starlets like Joan Crawford delivering strangely stern come-ons to depression-strapped readers of national magazines, with one for the All Year Club of Southern California proclaiming: *"Come to California for a glorious vacation. Advise anyone not to come seeking employment, lest he be disappointed; but for tourists the attractions are unlimited."* Studio wordsmiths began to incorporate local plot twists into their basic fare. The 1936 motion picture classic *A Star is*

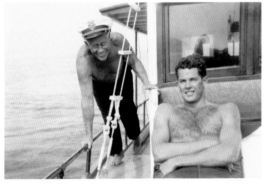

Born extolled the following on the opening title card: *"Hollywood / the beckoning El Dorado... Metropolis of make-believe in the California Hills."* When the fictional character of Norman Maine did his maudlin, self-sacrificial suicide walk into the surf, there wasn't a dry eye in the theater. For the Malibu guards who had to drag the body of real-life suicide victim John Bowers from the water, the idealized theatricality of the studio mill was sorely lacking. The lifeguards were unaware that Bowers's death would almost immediately become grist for a famous screen play which would be resurrected and released several times. In their working jargon the dead actor was "a floater" and constituted little more than business as usual.

NIGHTCLUBS AND GUITARS

Nightclubs near Santa Monica Bay reflected a rich musical interchange. Surfers tended to congregate at clubs like the Hula Hut, the Club Zamboanga, the

Hawaiian Paradise, Sweeny's Tropicana, the Coconut Grove, and the Holo Holo that specialized in true Hawaiian music. The Matson Steamship Line brought scores of Island players to the Los Angeles area (see page 38). They interacted with the local surfers, and it was a rare gathering that didn't have self-provided musical entertainment. Some members of surfing's elite who performed as musical professionals were Panama Dave Baptiste, Pete Peterson, Tom Zahn, Chick Daniels, Alfred Apaka, Splash Lyons, Squeeze Kamana, and Pua Kealoha.

Years earlier, a key figure among the island transplants was Sol Hoopii, the legendary steel guitar player. He developed a loyal following soon after his arrival on the scene, and among his fans was actress Mary Pickford. She would summon Hoopii to the movie set whenever she had to do a crying scene, and the master stylist's melodies would so move Pickford that she could produce torrents of tears on command. One can trace the evolution of the electric guitar from Hoopii's music to country crooner Spade Cooley to the sun-baked twang of Dick Dale's surf riffology of the six-

ties, which helped catapult the surfing lifestyle into a global phenomenon.

THE WAR

World War II terminated the idyllic Eden that James and his friends were immersed in. It was widely called the end of innocence. The raid on Pearl Harbor set the war machine into gear, and everything else had to get out of the way or be ground up. Gone were the fish camps, the mom-and-pop stores, the nurseries, and the homes and gardens of the West Side's Japanese citizens. In the country's quest for security, law-abiding members of the community were carted off to desert concentration camps.

The draft intervened, forever changing behavior codes, mating rituals, and societal expectations. Girls quickly became widows as boys were forced into being men, and many a GI romance ended with a new bride attending a ceremony for a flag-draped box. The easy life of the homefront vanished as rationing and scarcity

replaced unrestricted freedom and plenty. Four-hour car trips to Laguna or San Onofre now depended upon rare gas-rationing coupons.

Subsistence-level divers like Don's lifeguard friends Pete Peterson and Bob Butt, who had spent idle afternoons harvesting lobster off the coastal shelf, became the nucleus of the U.S. Navy's initial underwater demolition unit. Forerunners of the modern elit commando SEAL teams, their peacetime skills were case-hardened by the rigors of combat.

The ocean itself became off-limits to civilians as many of the spots that appear in this collection of photographs were sealed off in the name of defense. Malibu became a Coast Guard base. Point Dume was dynamited and occupied by military observers. San Onofre beach was pressed into duty as a Marine training area. Panic ruled the coast. The Elwood oil field near Santa Barbara was shelled by a Japanese submarine. Another marauding coastal raider surfaced off Ocean Park. In those tense times, entry into a gov-

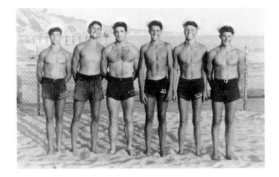

ernmentally controlled zone was treason, and possession of a camera led straight into the federal penitentiary at Leavenworth.

Though World War II ended the edenic beach scene shared by Don and his friends, it indirectly contributed significantly to surfing's explosion into mainstream culture. War-time innovation yielded a whole new crop of materials and technologies that were incorporated into surfboard design. Lighter materials such as fiber-glass, marine plywood, and balsa wood for building of boards made them considerably more user friendly, and new design techniques helped to develop the design of fins and their placement, bottom contours, spoon decks, complex foil, rail contours, and overall thickness flows that yielded the lighter, high-performance boards that are still the blueprint for surfboards today.

Wartime industry brought about other changes that were less beneficial to the region. Los Angeles County

was once the nation's wealthiest agricultural county, but the sacrifice of several thousand planted acres to satisfy the spatial requirements of post-war housing and freeway projects effectively eliminated significant agricultural production in the region. Unwise methods for disposing of unwanted industrial and military by-products during the crunch of the war effort continue to cause tremendous environmental concern along the coast. It is rumored that radioactive nuclear wastes dumped off Catalina Island at the war's end are now loose in the bay's fishery. In the 1970s, Santa Monica Bay was identified as one of the world's most mercury-contaminated sites. Don James's documentation assumes further importance because it records significant natural resources as they once existed, before their wholesale violation.

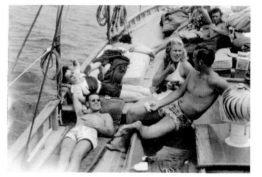

ON FILM

"I've never really done anything extraordinary; maybe I happened to be where things occurred a few times, maybe I happened to do a couple of things first." Such introspective self-analysis and humility typified Don's mind-set after documenting the surf lifestyle for six decades. His unique contribution is significant because of his consistent technological and stylistic innovations. To place his work in perspective properly, all one has to do is ponder the immensity of his archive. No one else can touch it in terms of continuity, technical command, innovation, or style.

Don had little desire to make claims of preeminence in the photographic field, but for the record, among the photographic innovations that he either pioneered or greatly expanded the use of for documenting the sport of surfing are these: extreme telephoto lenses, large and micro-mini formats, camera boards, extreme wide angles, water housings, tubal perspectives, gyroscopic mounts, single-lens reflex systems, motor-drive sequences, helicopter perspectives, boat perspectives, and telephoto water shots.

From the effortlessly idyllic lifestyle reportage of the 1930s and 1940s to the later ultracinematic, lushly detailed, participant's-eye perspectives of the 1960s and 1970s, Don James's approach consistently revealed the most integral aspects of the surfing experience. His images have become the icons by which the sport is identified, both within and outside of the culture. A claim can be made that he is the best known surfing photographer of all time, and the widespread replication and mass distribution of his images support the assertion. Covers on *Life* and *Der Spiegel;* numerous contributions to periodicals like *Time, The Saturday Evening Post, Honolulu,* and *Sports Illustrated;* and appearances on national television, billboards, and advertising campaigns are all are evidence of the prominence of Don's work.

THE DOCTOR

No celebration of Don James would be complete without a closer examination of his "other" career, the practice of dentistry. "I got interested in becoming a dentist because of Dr. Barney Wilkes and Dr. John Heath Ball. They were two outstanding men who surfed a lot and did something to help others. I was exposed to the lifeguards on the Santa Monica force, and the way they conducted themselves always impressed me. They were the first organized professional group of guards around, and they worked hard to establish a respect for surfing. I learned about the Hawaiian concepts of aloha and doing for others first from people like Johnny McMahon, Tony Guerrero, Duke Kahanamoku, Pua Kealoah, Hackshaw Paia, and, of course, Lorrin Harrison and Pete Peterson.

"It was Pete who gave me my first job, and he later took Cap Watkins aside and said, 'Look, the kid needs to be a doctor and we've got to help him.' That got me on as a Santa Monica guard. I'd attend school all day and work for the city all night on the pier. I had a scholarship from the Navy, so my grades had to be good. One failure and you were out of the program immediately. Being a lifeguard enabled me to get

through dental school, so I owe it all to Peterson and Watkins. If the university or the government had ever found out I was working another job, they would have washed me out straight away." The ordinarily circumspect dentist could, after much prodding, come forth with an assortment of humorous and entertaining tales of the tooth biz: There was the time romantic leading man Erroll Flynn, having just purchased the Lové Brassiere Company, arrived in the office wearing a bra (he was joking). In another incident, a pain-addled Clark Gable speculated about killing James's senior partner (he wasn't making a joke).

For many of his younger patients, and for two generations of surfing magazine readers, Don James was an example that terminal adolescence wasn't a requirement for being a true, hardcore surfer. Perhaps that was his most significant achievement.

Several years ago, Don salvaged these early photos from his garage, where they had remained in boxes and tattered scrapbooks for years. Soon afterwards, his best friend, Ed Fearon, living in Tahiti, sent Don his scrapbooks filled with photos of their years together on the beaches of Southern California before the war. At the time, Don and his wife Laura were renting a beach house at Rincon Point, a popular surfing spot just south of Santa Barbara. One evening, while taking his ritual sunset walk on the beach, Don ran into his Rincon neighbor, Tom Adler, and mentioned the recent find of forgotten snapshots. They had often talked about doing a book together, and they now had the material. I had known Don and Tom for years and was eager to help with the project. We spent many hours with Don as he remembered his old friends, first cameras, and the wonderful stories surrounding these photos. His recall was amazing, but his eyes were giving out. If he was to see the finished book, the production schedule would have to be stepped up. A few days before Christmas 1996, the books arrived. The short run edition included five hundred copies which were numbered and then signed. Two days later, he died in his sleep in the privacy of his home above Santa Barbara.

PLATES

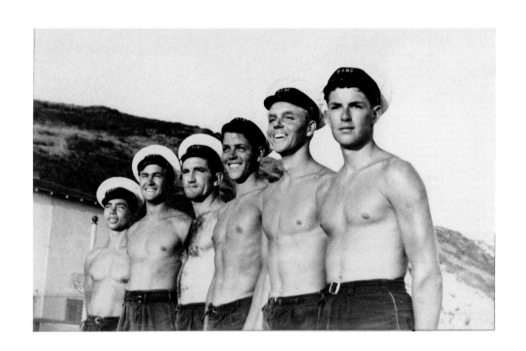

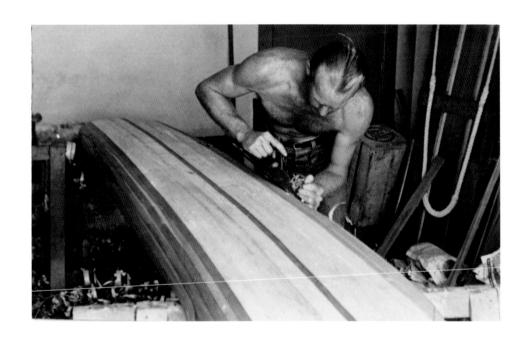

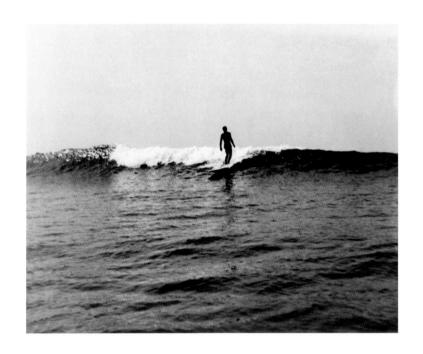

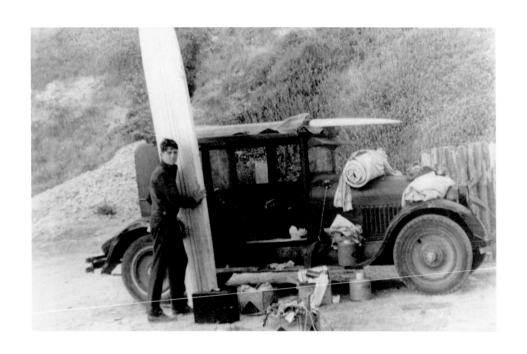

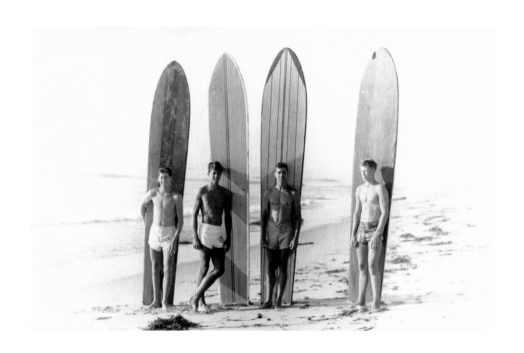

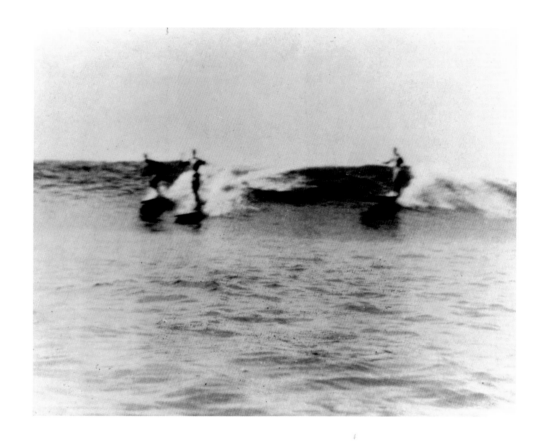

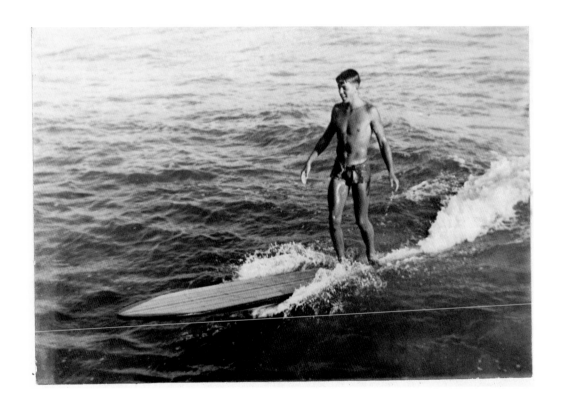

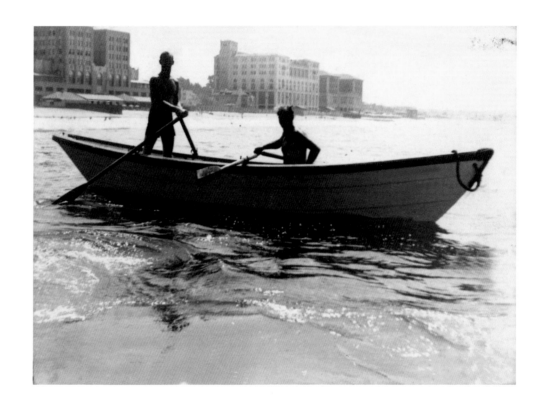

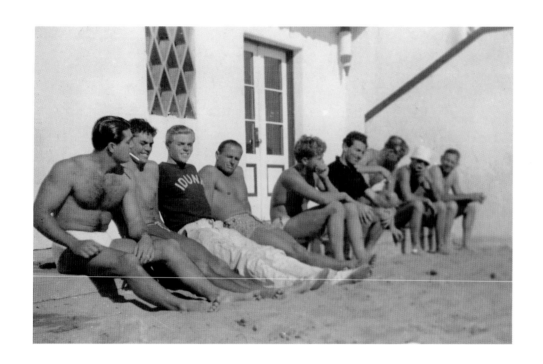

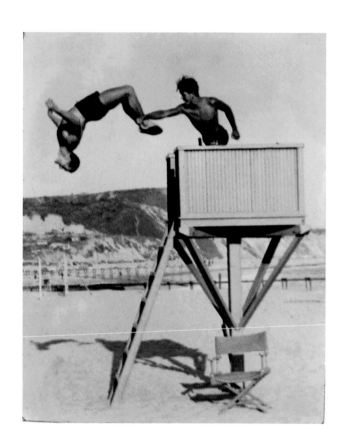

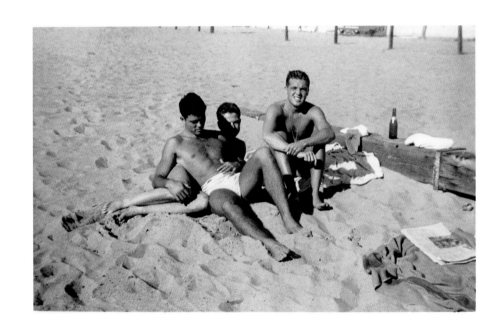

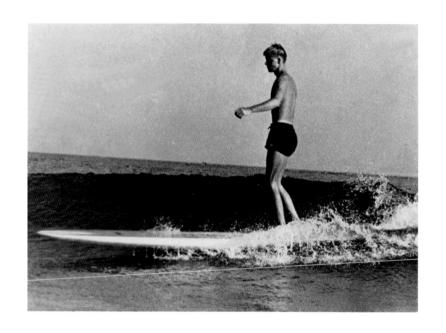

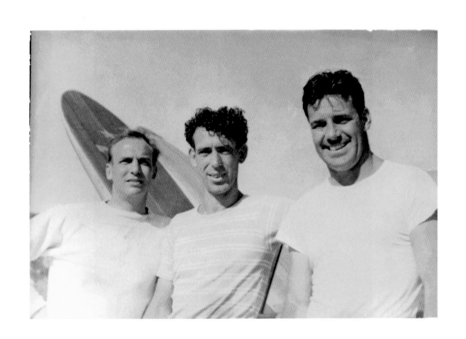

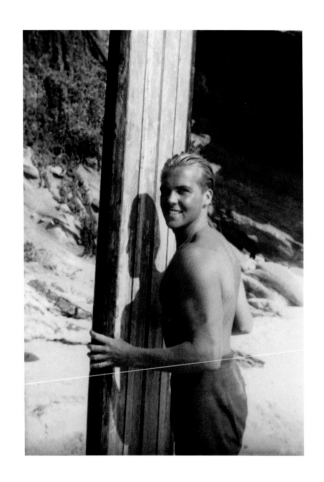

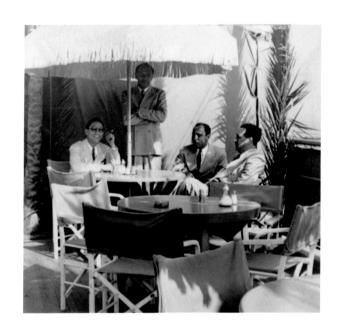

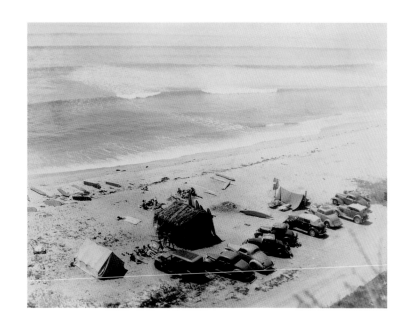

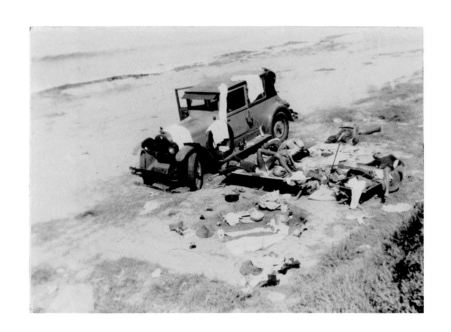

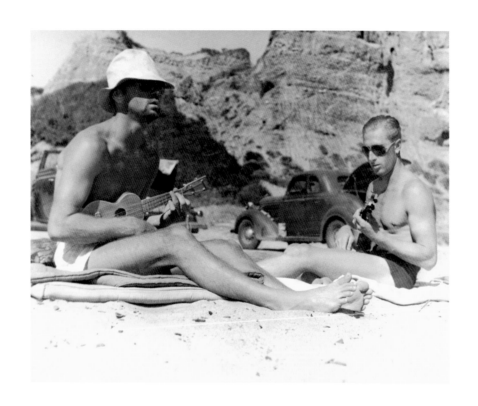

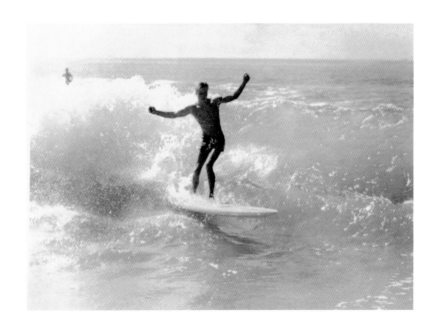

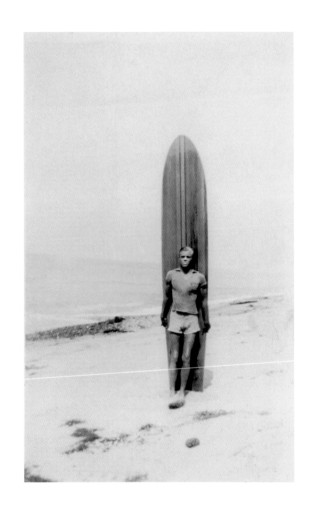

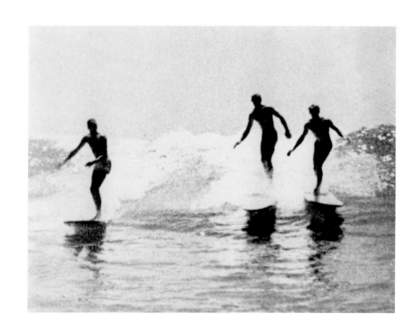

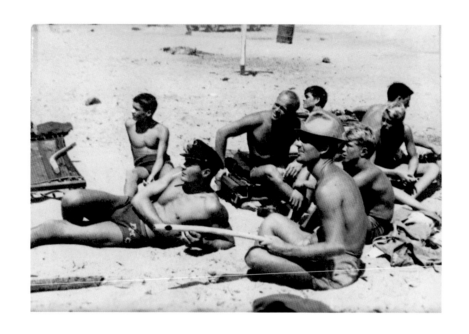

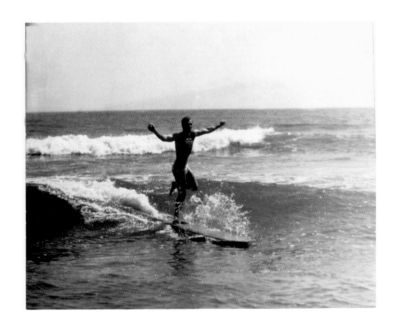

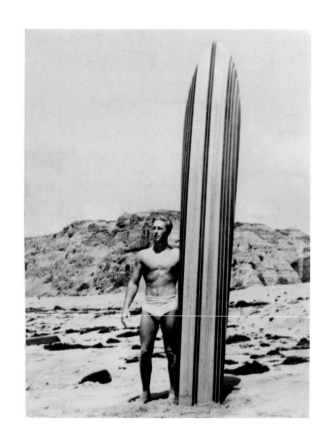

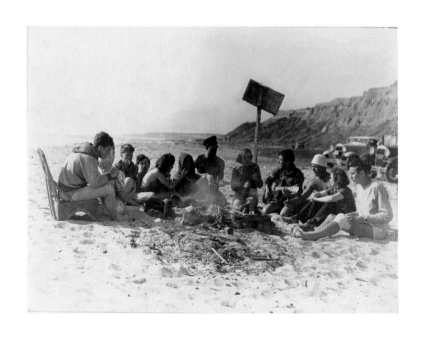

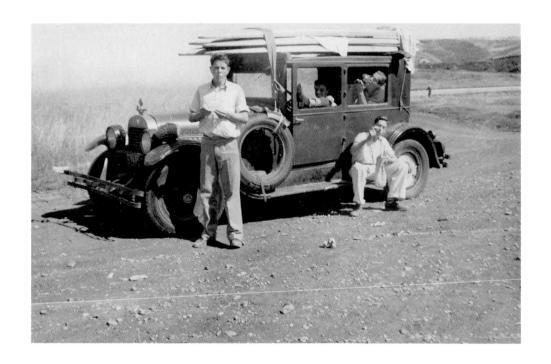

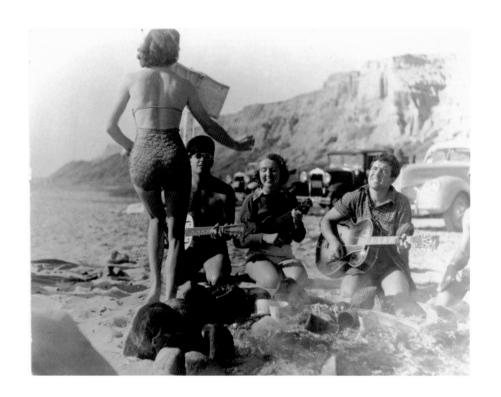

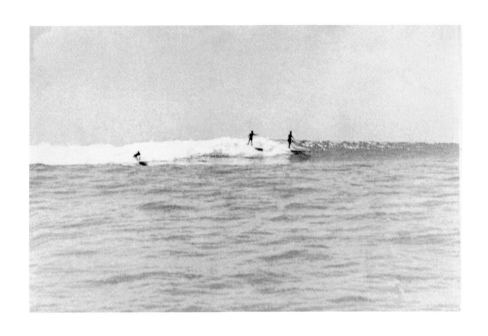

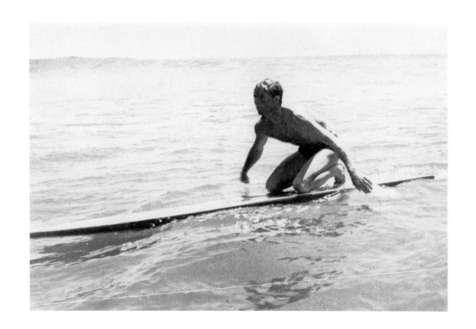

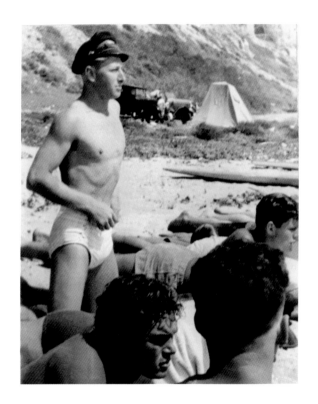

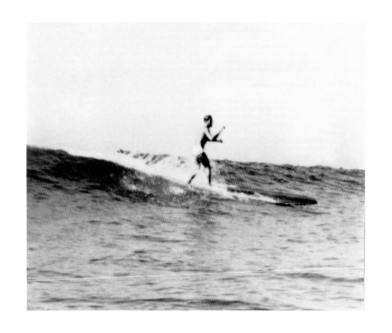

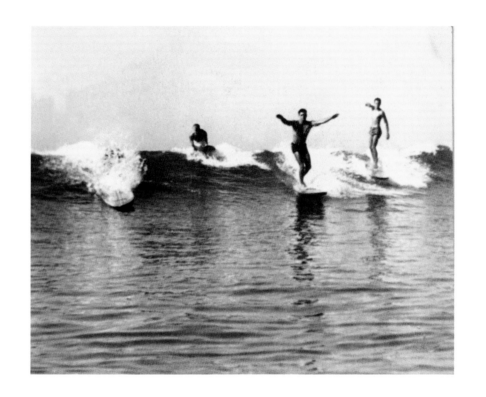

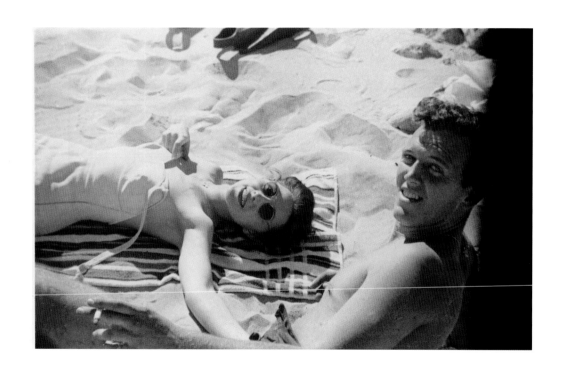

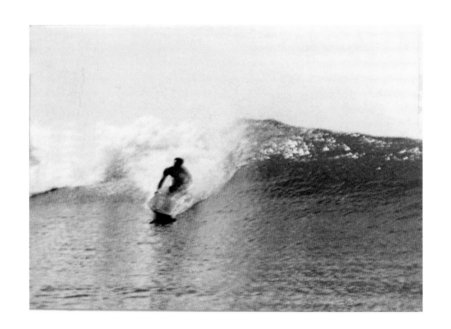

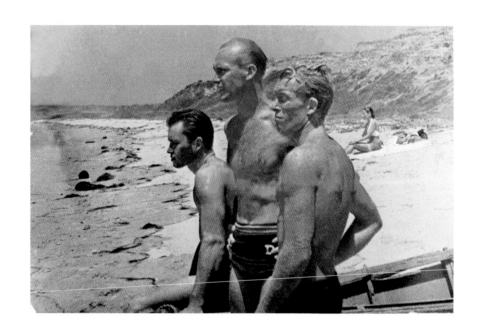

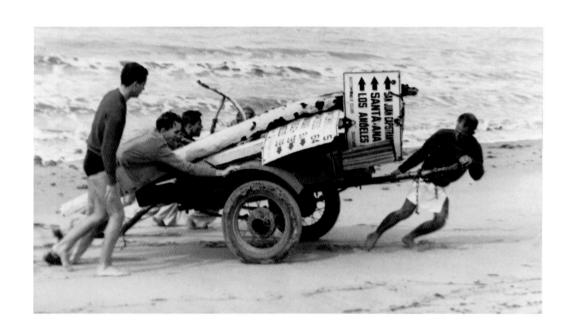

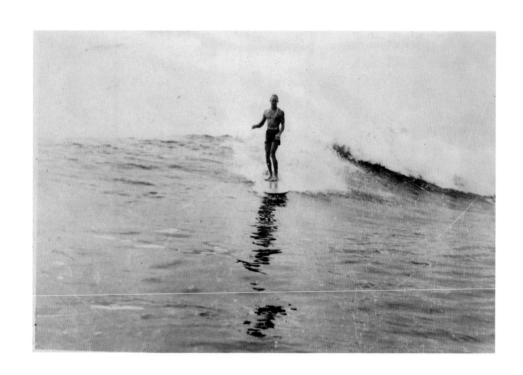

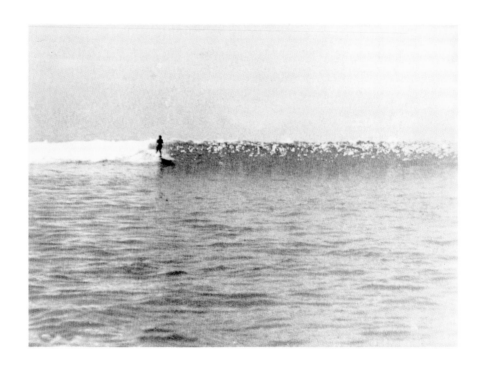

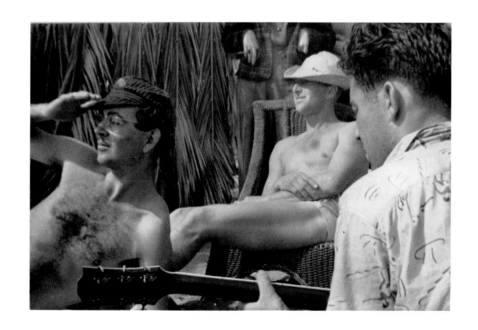

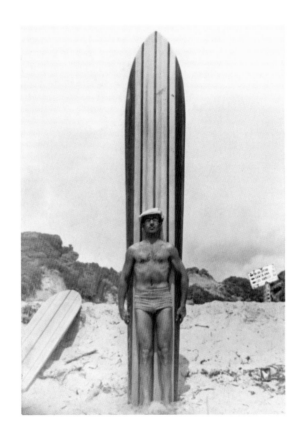

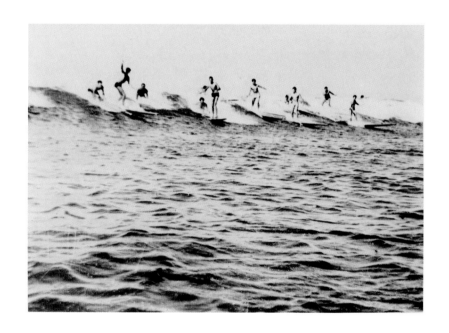

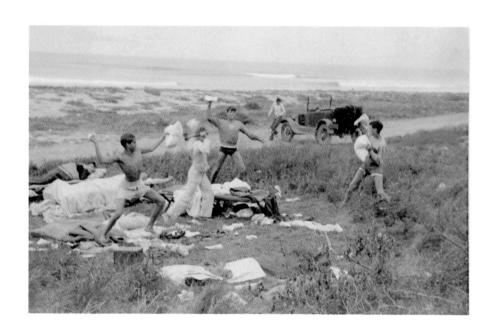

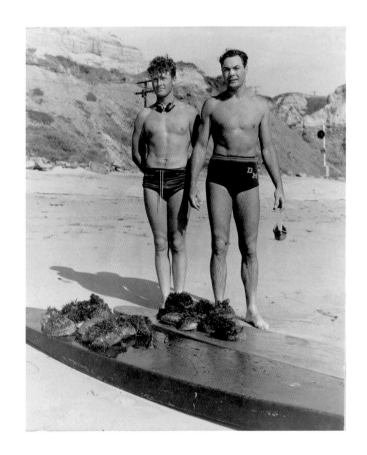

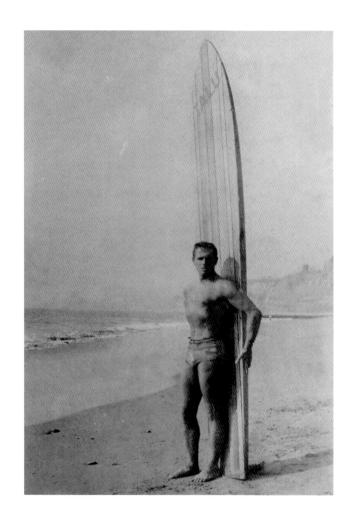

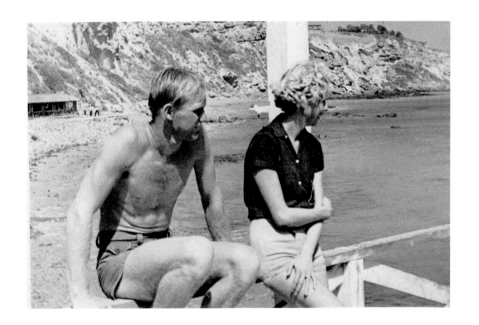

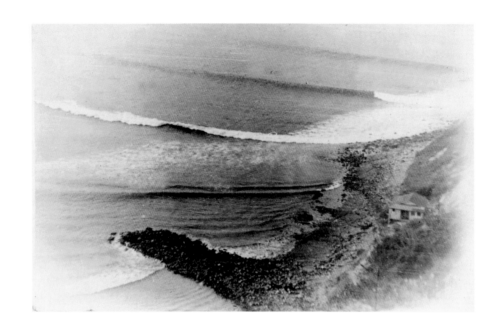

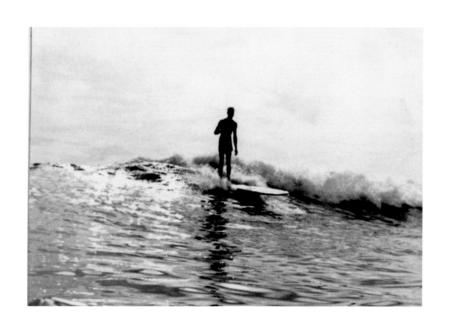

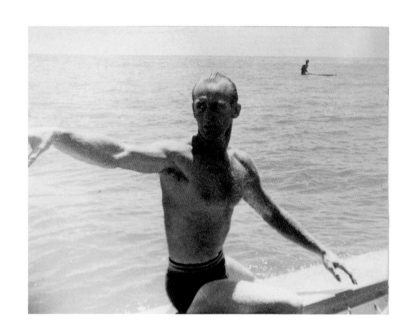

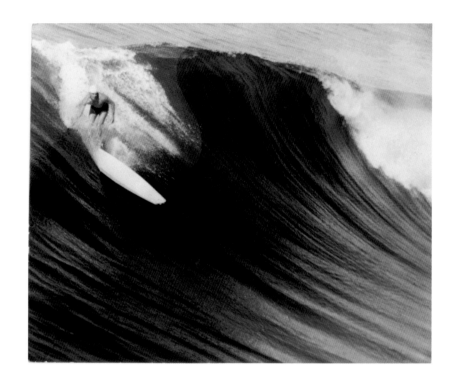

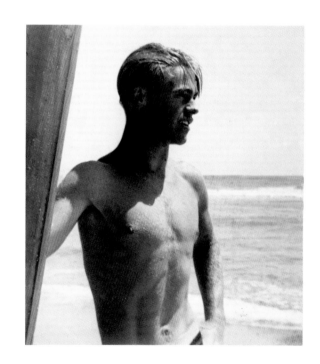

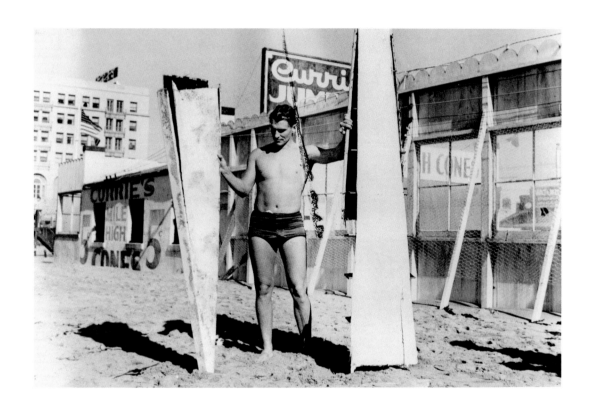

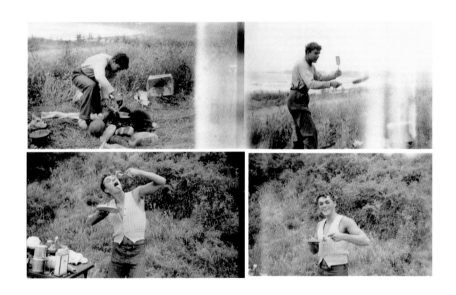

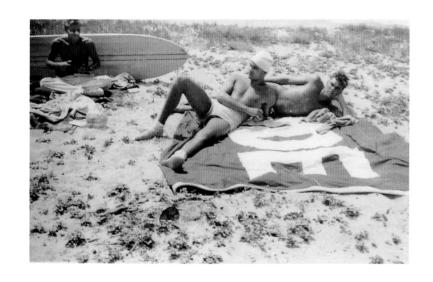

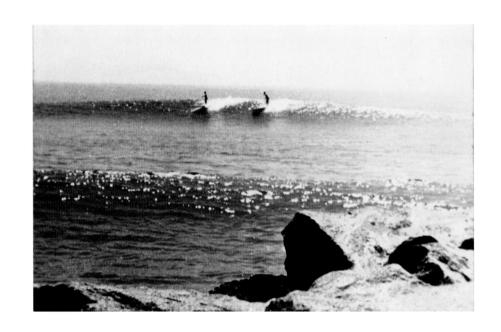

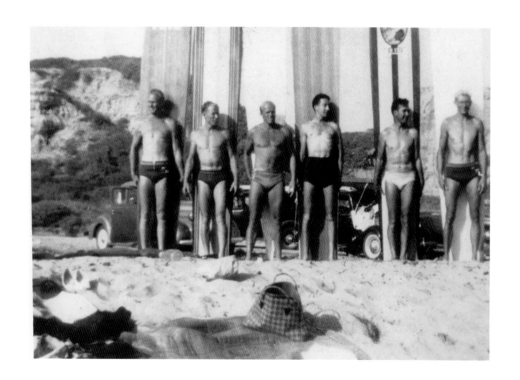

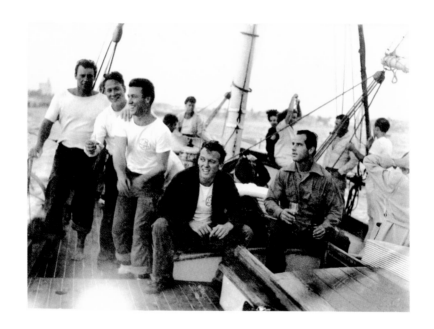

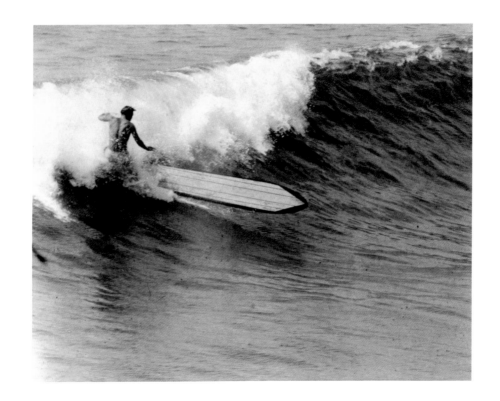

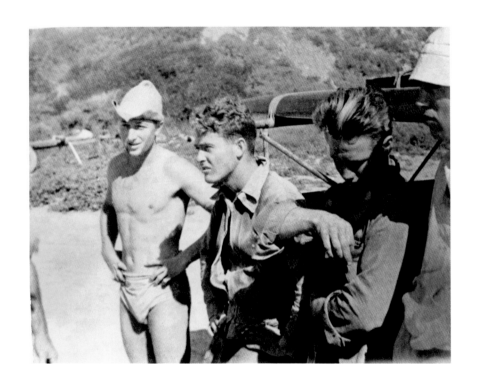

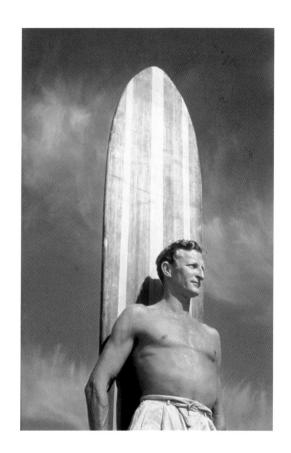

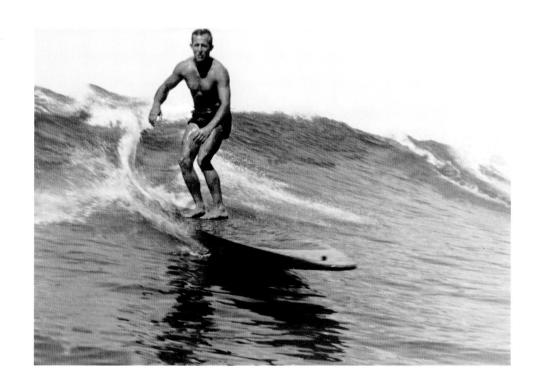

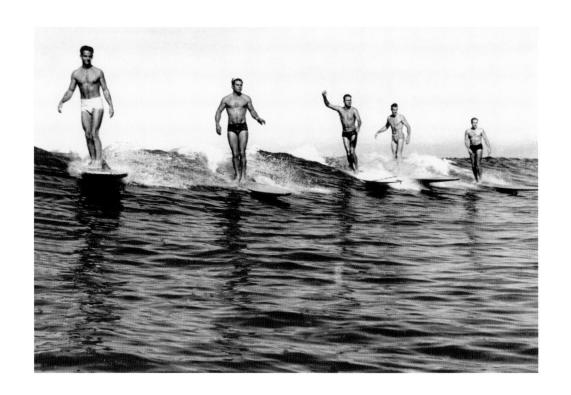

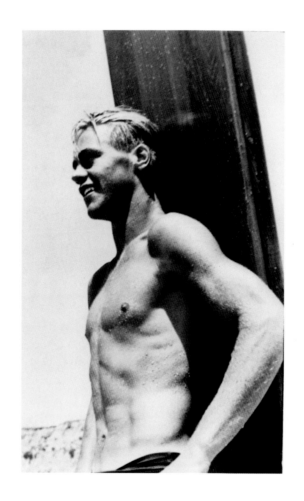

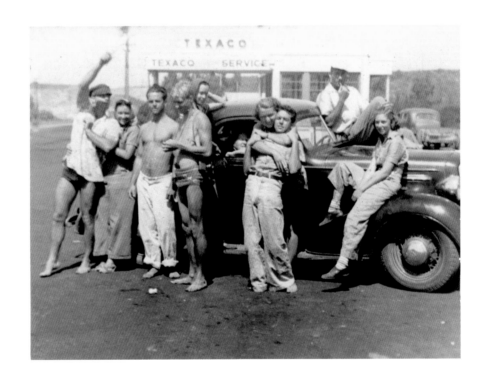

90

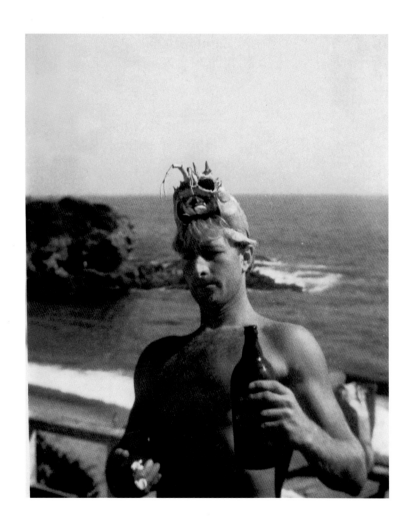

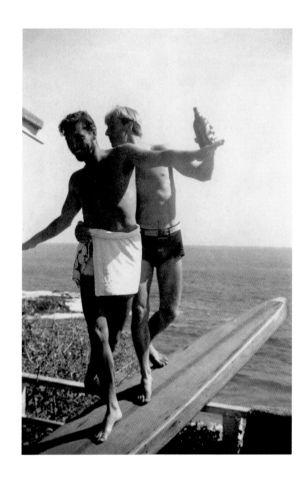

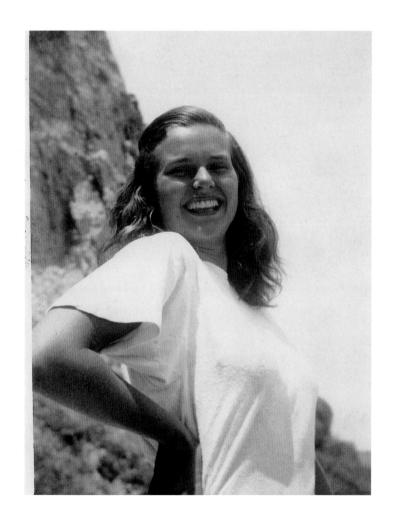

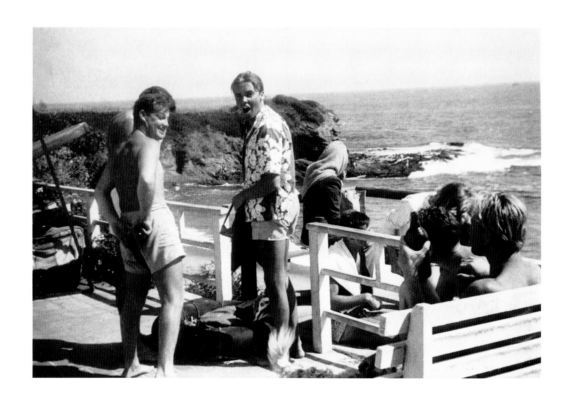

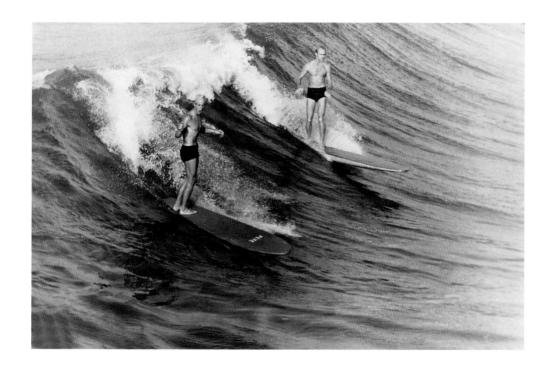

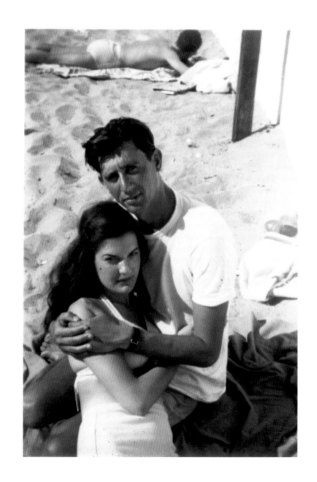

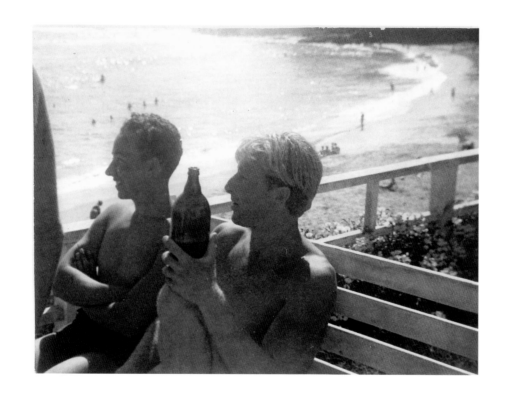

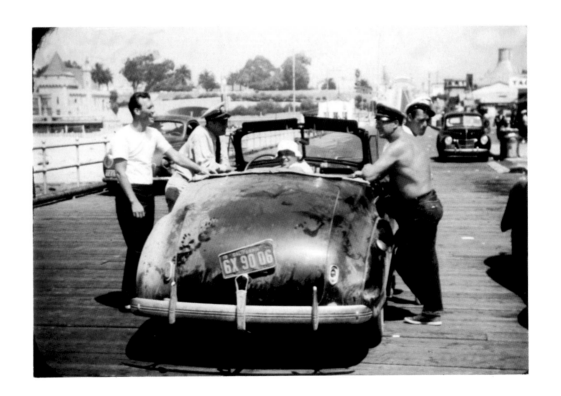

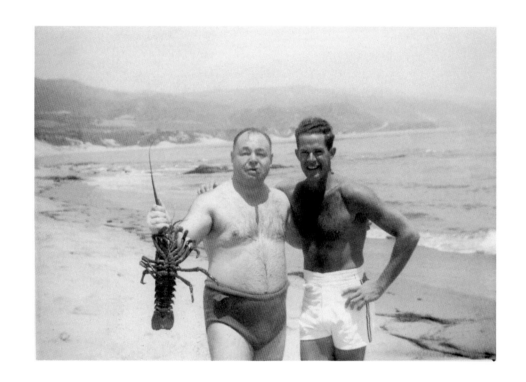

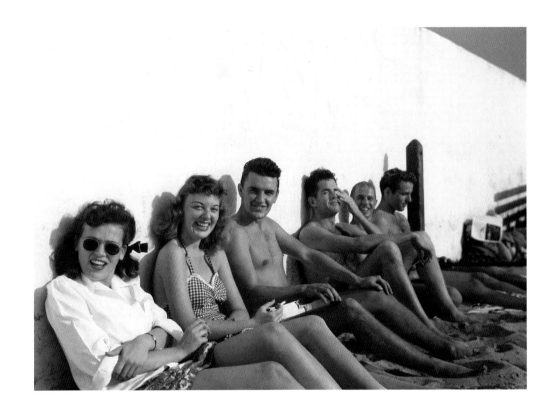

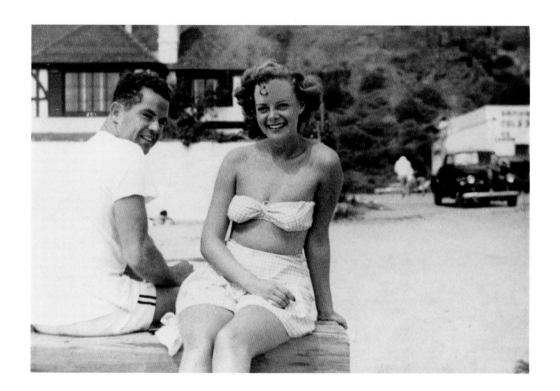

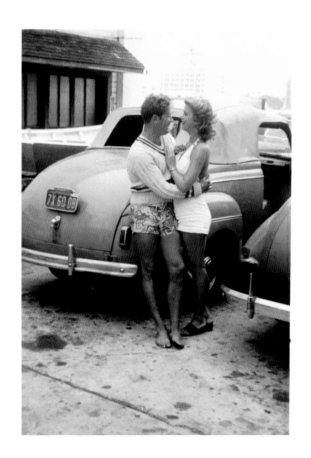

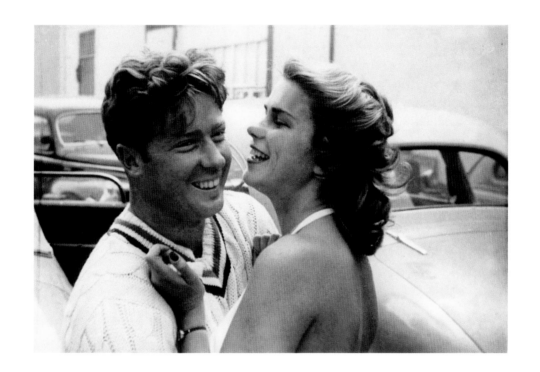

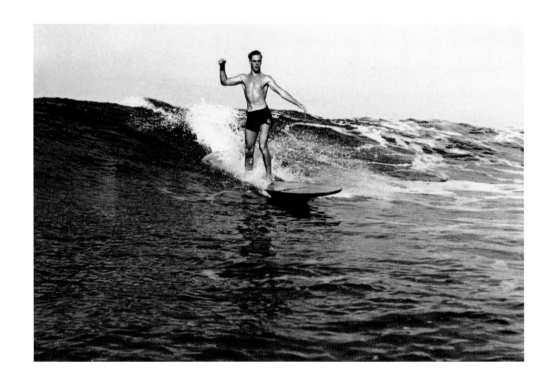

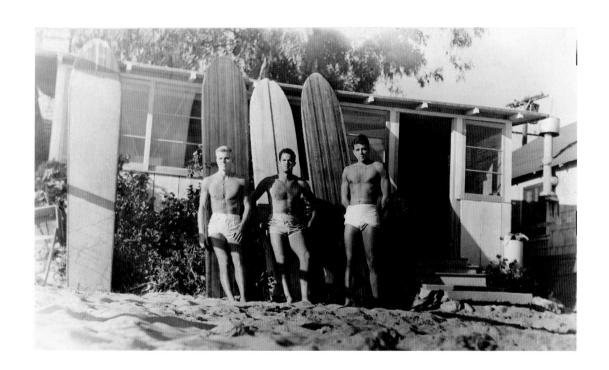

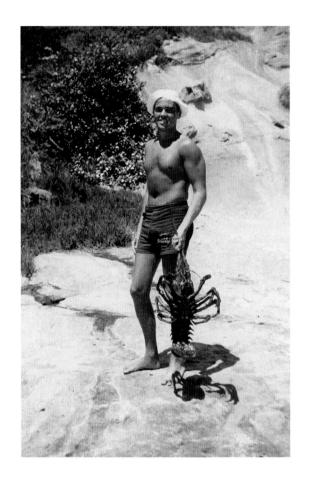

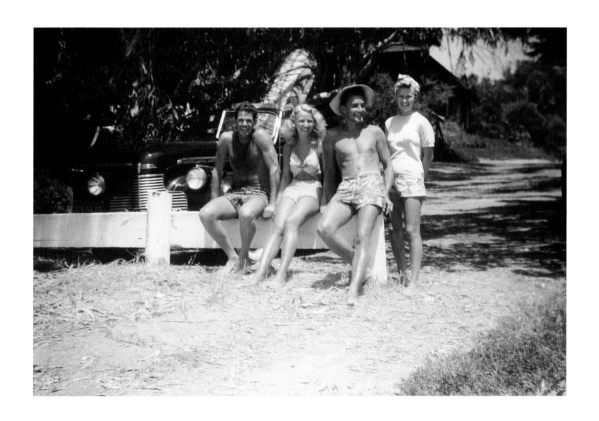

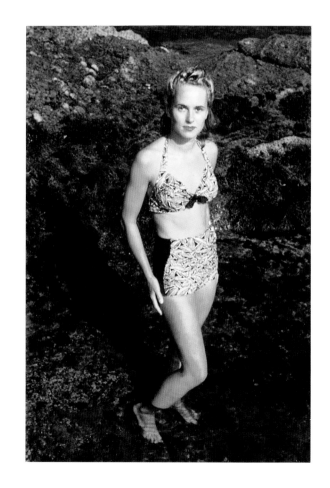

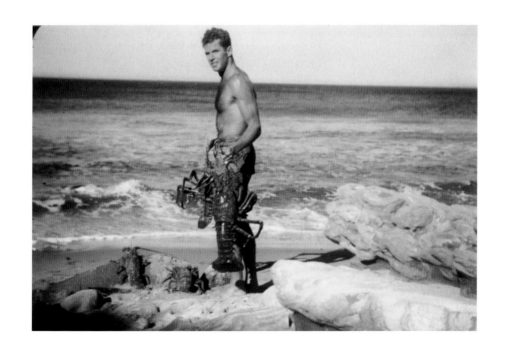

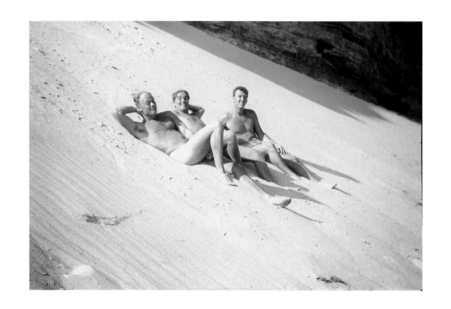

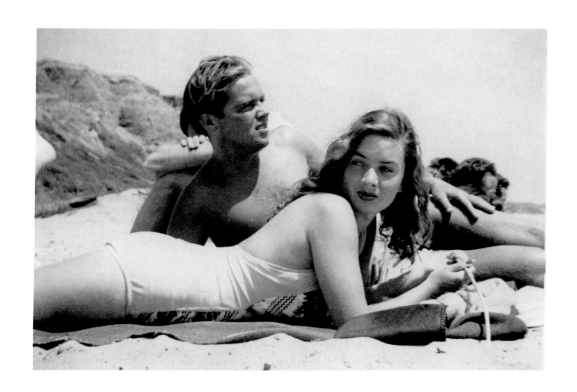

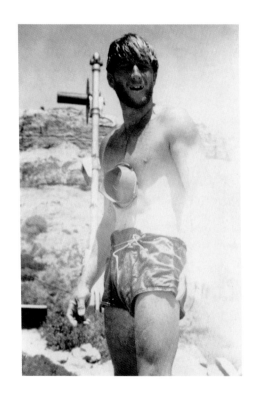

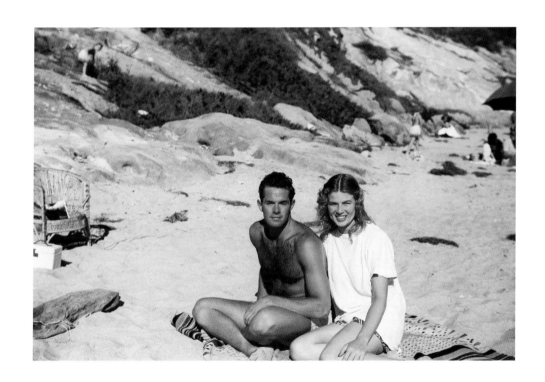

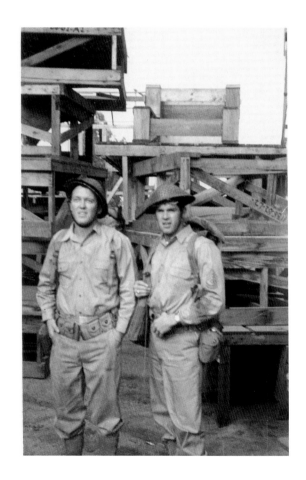

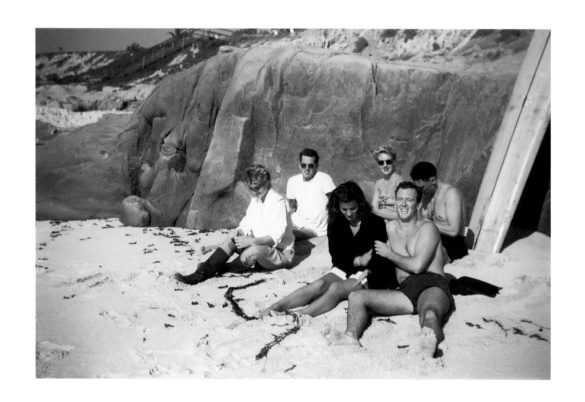

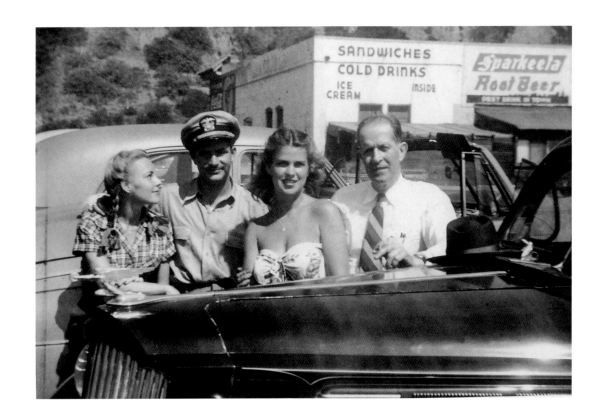

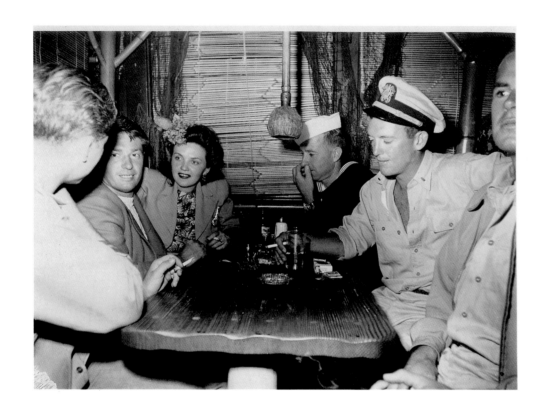

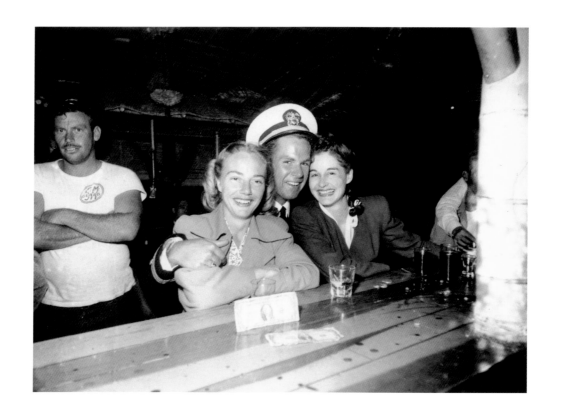

NOTES

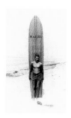

PAGE 8 1936 San Onofre. Don James with the Kailua.

COVER 1937 San Onofre. George "Peanuts" Larson and an unknown.
Peanuts is seen here demonstrating his unique one-footed stance. This was
one of my early efforts at water photography, which could then only be
successfully accomplished in smaller waves under ideal conditions. Later
on we began building waterproof housings to protect our cameras, which
greatly expanded the possibilities. For this shot I only had a towel to shield
my camera. The regular loss of equipment somehow enhanced my enjoy-
ment of the few shots I managed to get. The guys in the pawn shops loved
it. "Hey, here comes the kid – he sunk another one."

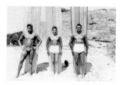

PAGE 9 1938 Fred Beckner, Don James, and Chuck Eddy. Chuck's mother
owned the Culver City Rollerdome, so he was always a key figure in the
organization of social hi-jinx.

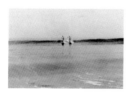

OPPOSITE TITLE PAGE 1937 State Beach, Santa Monica. Box camera.

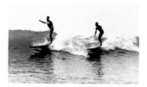

PAGE 10 Barney Wilkes and an unidentified friend.

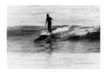

PAGE 11 1938 State Beach. Bud Morrisey was one of the premiere surfers of the time, and he used to take us kids to Palos Verdes Cove in the mid-thirties. The manner in which Bud rode was very advanced; he was turning and walking the board early on.

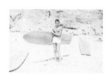

PAGE 12 1937 San Onofre. Don James. A slightly guilty Don James can be observed immediately after removing his leg cast. A week of success in the surf while wearing a paraffin smeared plaster cast had falsely encouraged me that my broken leg had healed. It hadn't. Close inspection of this photo will reveal the increasing distension in my left leg. Moments later my friends had to fashion a splint from driftwood and rush me to the closest general practitioner.

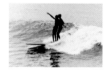

PAGE 13 1939 Bel Air Bay Club Jetty. Jack Quigg and Ed Fearon. We all worked there for three bucks a day, ate free, and surfed while on duty. This picture was taken from the Bel Air jetty. Ed was giving Quigg a ride into shore after Jack had lost his board.

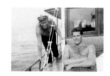

PAGE 14 1942. Off Malibu coast on the way to Point Dume. Cap Watkins and Don James.

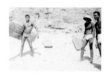

PAGE 15 1937 San Onofre. Left, Fred Beckner, Al Hoole, and Chuck Eddy.

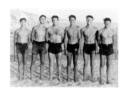

PAGE 16 1938. Bel Air Bay Club crew.

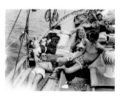

PAGE 17 1942. On another trip to Catalina aboard the *Zarak*.

PAGE 18 1939. Hugo Walters and Freddy Zehndar.

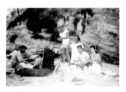

PAGE 19 1942. An abalone bake picnic at Point Dume.

PLATES

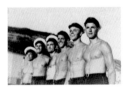

PAGE 22 1938 Bel Air Bay Club. Ed Fearon, Jack Quigg, Popeye, Chuck Carter, Dick Reed, and Don James. The Beach Services brigade was always ready to serve.

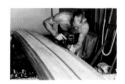

PAGE 23 1938 Santa Monica. Pete Peterson. This is Pete shaping my first Peterson board in his garage on 17th Street. To earn this shape job, I labored for Peterson for a full year as his lawn boy, babysitter, and aide-de-camp.

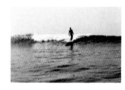

PAGE 24 1937 San Onofre. Jack Quigg.

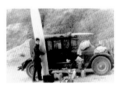

PAGE 25 Joe Quigg at San Onofre on a weekend campout.

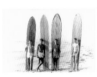

PAGE 26 1939 Malibu. Ralph Kiewit, Jack Quigg, Dick Reed, and Roger Bohning. A summer Sunday morning at Surfrider Beach.

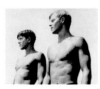

PAGE 27 1937 San Onofre. Jack Quigg and Ed Fearon.

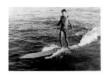

PAGE 29 1938 Bel Air Bay Club Jetty. Jack Quigg.

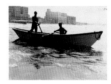

PAGE 28 1937 Palos Verdes. Ed Fearon and Bud Rice. This is my first water shot. I had seen some pictures taken from the Moana Hotel Pier in Waikiki that had a great "high over the water" perspective. I was so inspired that I seriously considered building a scaffold in the surf at Paddleboard Cove to shoot from. Finally I decided to shoot a surfer's point of view, straight on, off a board. It seemed easy, so I just paddled out holding my camera with its strap in my teeth. This wave came, I snapped the shutter release, and then dutifully clamped down on the Kodak's pigskin strap with my molars. When the wave hit me I bit clear through the strap and the camera bounced off my surfboard deck, but miraculously it didn't wash overboard. After that I thought, "Hey, there's nothing to this." I couldn't count how many camera rigs perished later as I attempted to expand upon this photograph. It's sixty years later and I still occasionally drown one.

PAGE 30 1937 Santa Monica Pier. Pete Peterson and Cap Watkins. This was shot from a bosun's chair that was suspended off of the pier. In the background the Hotel Monica, the Jonathon Club, and the Del Mar Club can be seen. To the right of the Del Mar club is the old Bay Street lifeguard headquarters, where during the off-season guards would illegally bunk to save money. There wasn't much available at the beach in terms of steady employment back then. Before the Santa Monica municipal guard service was formed in the thirties, surfers worked sporadically at the beach clubs as guards, but that was about it.

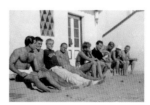

PAGE 31 1937 Lifeguard Headquarters, State Beach. Barney Wilkes, Ed Fearon, and some of their friends.

PAGE 32 1937 Santa Monica. Freddy Zehndar. Freddy was an impressive character who used to execute flat swan dives like this, in a couple of inches of water, to amaze the young lovelies. He was an Olympic team swimmer during the 1920s, and he later worked as the head stunt diver on the movie *Jaws*.

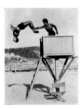

PAGE 33 1938 Bel Air Bay Club. Jack Quigg and Popeye. Popeye flips as Quigg makes contact, all done for the effect.

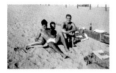

PAGE 34 Jack Quigg, Joe Seward, and Hugo Walters. Jack was a superlative athlete. Once at UCLA, Quigg was goofing around in the broad jump pit, when a football flew over from the adjacent field where the varsity team was working out. Jack was barefooted, and he kicked the ball in a perfect high spiral arc all the way to the end of the other field. It was a magnificent feat. The head coach came running over immediately and asked Quigg to come out and join the squad. Jack ignored the coach and uttered some undecipherable grunt and walked away. The coach was quite taken aback; here was this incredible prospect who wouldn't even acknowledge his offer. We used to call Quigg "Indian Jack" because he was so stoic; he never said much of anything.

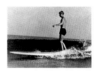

PAGE 35 1939 San Onofre. Ed Fearon. This view of Ed on his state-of-the-art balsa-cored mahogany-decked Peterson board was taken by wading out with a Graphlex. Fearon is my best friend, and he lives in Tahiti, where he still swims every day.

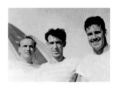

PAGE 36 1937 San Onofre. Jackie Coogan, John McMahon, and Bob Butt. Jackie Coogan was an actor who'd earned a fortune as a child star. As an adult he had to sue his parents for misappropriation of his funds. He didn't receive a lot, but because of his case, there are now laws protecting minors' wages. Coogan was relatively philosophical about the fiasco, and he was able to live in the Malibu Colony, where he surfed regularly. Back then, Malibu Point was fenced off and there was no public access. Since Jackie's house in the Colony was just a couple of hundred feet from the best waves in the world, he considered himself to be extremely fortunate. Coogan let us come up to his house and surf, and he remained a great guy despite the emotional rollercoaster he was on. In later years, when Jackie's

career had resurrected itself and he had become a highly recognizable star on the *Addams Family* television show, we would laugh about those quiet times in the Colony. Once when Coogan came to ride Malibu during the show's zenith in the sixties, he was mobbed by scores of kids chanting "Uncle Fester, Uncle Fester."

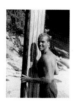

PAGE 37 1938 Point Dume. Hugo Walters.

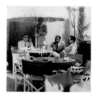

PAGE 38 1937 Bel Air Bay Club. Dick MacIntyre, Johnny Pineapple, and two other members of the Royal Hawaiian Band, a favorite of ours.

PAGE 39 1939 San Onofre. I can date this shot because Eddie McBride's 1939 Dodge is visible. McBride was a surveyor who bought a new Dodge every year on the second of January, like clockwork. He possessed a lucrative contract from the federal government's Geological Survey to take depth soundings along the entire coast. The fact that Eddie rowed a dory eight hours a day, five days a week, during the course of his work also meant that he was in phenomenal physical condition.

PAGE 40 1937 San Onofre. Bud Rice and Don James. This was taken by Ed Fearon right after I had bought the '25 Hudson we christened the "Wreck." The old buggy is sporting a fresh coat of paint that my dad applied with a portable disposable spray canister. We used to tour with a cache of used tires. "Used" for us meant tires that had been tossed out by garages as being worthless. A typical trip to San Onofre usually involved four flats, which required that we take the wheel apart and remount another tire. When we were lucky, we could patch a small hole in the tire by wedging in a boot heel and thus avoid the hassle of removing the wheel from the car.

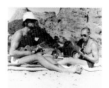

PAGE 41 1937 San Onofre. E. J. Osher and Peanuts Larson. Ukuleles were de rigueur at San Onofre in '37. E. J. can still be found at San Onofre on most weekends playing his uke and riding waves.

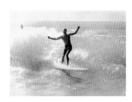

PAGE 42 1939 San Onofre. Ed Fearon. Ed Fearon shoots the San Onofre shorebreak at the site of the current Southern California Edison nuclear power plant cooling water outflow pipe.

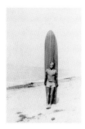

PAGE 43 January 22, 1936. Ed Fearon. This balsa and redwood board was dubbed "The Stinton Spinner" after its maker, John Stinton. Since they had no fins and wide flat tail sections, they spun out easily. We purchased these boards for twenty dollars, sanded and unvarnished.

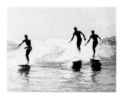

PAGE 44 1937 San Onofre. Horatio, Pete Peterson, and Lorrin Harrison.

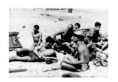

PAGE 45 Doakes, John Stinton, Adie Bayer, (rear) Bob Burns, Frank Powers, and Ralph Kiewit.

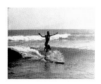

PAGE 46 Peanuts Larson with his famous one-footed stance.

PAGE 47 1939 San Onofre. Peanuts Larson with a balsa and redwood board.

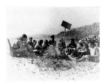

PAGE 48 1937 San Onofre. Left to right: Bill Lytell, Benny Merrill, George Brignell, Sarah Ferber, Steve Dingle, Barney Wilkes, Janice Turner, Bruce

Duncan, Eddie McBride, Betty Simpson, and Slim. Campfire song sessions provided entertainment in the dark ages before portable electronic amusements.

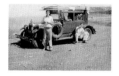

PAGE 49 1937 San Onofre. Jack Quigg (standing), Don James, Ed Fearon, and Ralph Keiwit (on the running board). This 1925 Hudson was purchased from my uncle on the installment plan. It took two years to pay it off. Note the 2x4 lumber racks with the vulcanized innertube bands.

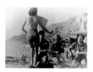

PAGE 50 1939 San Onofre. Eleanor, Barney Wilkes, Katie Dunbar, and Bruce Duncan. Informal jam sessions like this are still going on at San Onofre. The reverence for Polynesian culture can currently be seen in the San O' grass beach hut, which is flanked by carved Hawaiian gods.

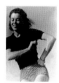

PAGE 51 1939 San Onofre. Eleanor. Hawaiian music and dance were extremely popular at our surfing beaches in the thirties and forties. Every-

one wanted to go to the islands and experience the culture firsthand. Ironically, the war sent many to the tropics, but the net results were a bit different than the dreamers had anticipated.

PAGE 52 San Onofre. Jimmy Reynolds, George Larson and Mary Ann Morrisey. Real women surfed and were highly capable athletes. Eighty-pound boards were difficult to carry and to ride. Anyone who mastered them was respected by all. Mary Ann ranked at the top. Decades later when the cheesy Hollywood surf exploitation movies came out, the status of beach women was reduced to a very stilted T&A schtick. The portrayal of male wave riders was marginally better. For example, try Buster Keaton meets Annette of *The Mickey Mouse Club* and Frankie "Moondoggie" Avalon from South Philly at the rock in Malibu (which in reality is a papier-mâché boulder on a back lot somewhere in Studio City).

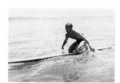

PAGE 53 1937 San Onofre. Lorrin "Whitey" Harrison. Lorrin was paddling in preparation for the upcoming Pacific Coast Championships. Training for watermen like Whitey consisted of simply surfing every day. He and Peterson vied for the top ranking at the contest every year. One year, during Lorrin and Pete's reign, Cliff Tucker from the Palos Verdes Surfing Club took it and everyone was astounded. Tucker was a good

surfer who introduced strategy into the competitive scene the year he took the title. During the preliminary heats earlier in the day when the wind was calmer, he rode a lighter more maneuverable board. Later for the finals, which were held in choppy conditions, Cliff used a heavier board that wasn't affected by the wind and bumps. No one had ever thought of doing that before.

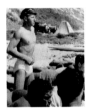

PAGE 54 1939 San Onofre. Peanuts Larson. Larson is modeling a pair of Doc Ball designed surf trunks. They afforded freedom of motion and were as durable as all get out. The mass-produced "swimming trunks" that were sold during the period could not withstand the thrashing that surfers subjected them to. Ball showed us the pattern and we all stitched them up. The campsite visible in the background shows how savvy guys used to pitch their tents in the eel grass and ice plant so they wouldn't get sand in their sleeping bags.

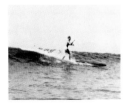

PAGE 55 1936 San Onofre. George "Peanuts" Larson.

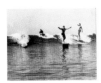

PAGE 56 1937 Palos Verdes Cove. Freddy "Terangi" Beckner and Adolph.

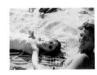

PAGE 57 1938 Neeny's. Julie and Frank Donahue. At the top of this photograph a pair of swim fins can barely be seen. This was the day Owen Churchill had come down to the beach at Santa Monica and had gifted us with his newly invented swim fins. These amazing devices suddenly enabled a weak swimmer to out-speed a champion. Churchill's handy fins found great favor during the war with the military. These pliable prewar natural rubber models were highly prized, as the later war-issue ones were made from a stiff synthetic rubber that did not float.

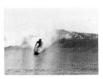

PAGE 58 1937 San Onofre, Jackie Coogan. Jackie used to bring his wife, Betty Grable, with him to San Onofre, and she would complain constantly, saying things like "get me off this filthy beach." We were never sure what reception might await us when we walked through the couple's Malibu Colony house on our way to Surfrider Beach. One day Coogan had

sold all of Grable's furniture without her permission and then used the proceeds to purchase a new Mercury convertible. Jackie's transgression instigated a tremendous argument. He came out in the water to surf and said, "Well, boys, it looks like I'm going to have some extra time on my hands; I think I'll chrome my new motor." I never saw Betty again except as a pin-up on other sailor's foot lockers.

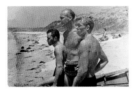

PAGE **59** Stan Bowen, Pete Peterson, and Whitey Harrison. Bowen was a fisherman from Dana Point. Peterson and Harrison were the two best surfers in California in the 1930s. Each of them had won the prestigious Pacific Coast championship. Both were incredible watermen who excelled at diving, canoe surfing, sailing, swimming, body surfing, tandem riding, fishing, and boat and board building, in addition to conventional stand-up surfing.

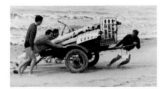

PAGE **60** San Onofre. Road signs washed ashore from various points along the Pacific Coast Highway during a big storm provided firewood for cold San Onofre regulars to warm themselves.

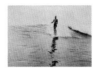

PAGE **61** 1938 Dana Point. Pete Peterson. Pete was a neat freak who never used any wax on the surface of his board for traction because he felt it violated the pristine look he so admired. This was unheard of, for everyone else used wax. Some were so obsessed with obtaining a non-slip surface that they even put sand in their varnish. Peterson's decks were very slick, but he learned how to place his weight very deliberately and somehow wouldn't slip off. Through this strange affectation, Pete developed the most precise wave positioning around. I guess it was all about his sense of order.

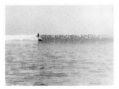

PAGE **62** 1937 San Onofre. Jack Quigg. Jack is riding a Pacific Systems Homes manufactured balsa and redwood board.

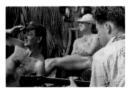

PAGE **63** 1938 San Onofre. George "Nellie Blye" Brignell, Peanuts Larson, and Bruce Duncan. Larson is clutching a packet of cigarettes, which was

a required accessory of the active sportsman back then. Unfiltered Camels and Lucky Strikes were the athlete's choice in the days before we knew any better.

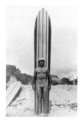

PAGE 64 1938 San Onofre. "Nelly Blye" Brignell. This board was built by Lorrin Harrison, and it displays the distinctive three stringer pattern that was later adopted by sixties legend Phil Edwards for use in his highly popular signature model surfboard. The tri-stick look retains connotations of prestige and status today.

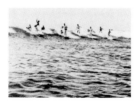

PAGE 65 1937 Bluff Cove, Palos Verdes. Bob Side, Jack Quigg, Eddie McBride, Ralph Saylin, Bud Rice, Jack Power, Doc Ball, and Hoppy Swarts. This was a real line-up of some of the well-known people who used to go to the cove. Doc Ball, a dentist, founded the Palos Verdes Surfing Club and held their meetings at his office on Vermont and Santa Barbara Streets in Los Angeles. We were members of a loose-knit group called the Del Mar

Surfing Club that didn't really have meetings. There was a patch and that was about it. The PVSC was very organized; guys had color-coordinated sweats with their name on them. The Del Mar people used to think that surfing was definitely not a team sport. Maybe we were just jealous of those plush outfits. There were some very hot riders in the PVSC, like Doc, Cliff Tucker, Tulie Clark, Leroy Grannis, and Hoppy Swarts. All in all we were friendly toward each other and had some great times together.

PAGE 66 1936 San Onofre. Jack Power. We never thought about skin protection from the ravages of ultraviolet radiation. A severe sunburn was considered a sign of good health. Jack was a redhead, and even in this black-and-white shot you can clearly see the result of Power's spending five days in the sun at 'Nofre without the benefit of shelter. As a group we were a dermatologist's nightmare.

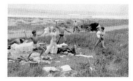

PAGE 67 1938 San Onofre. Surf camp. A prototypical food fight breaks up the status quo of camp life. Reinforcements can be observed rounding the Model T. The surf fashion craze of the extremely wide bell bottom pant can be seen here as well. We used to buy them in Santa Monica at Brauns

and then have a tailor let them out. They got progressively wider and wider, and eventually they caught on with the pachucos in the barrio. Once that happened, they were out at the beach.

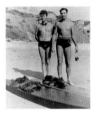

PAGE 68 1939 San Clemente Reef. Tommy Gray and Chas Butler. Gray and Butler were early diving innovators. They improvised their own masks and other aquatic implements long before such devices were produced for the recreational sport market. The first Aqua-Lung was sold from a shop in Westwood, California, owned by Rene Busoz, just after the Second World War. It was in the fifties that the diving boom really got started.

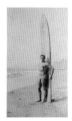

PAGE 69 1937 Freddy Zehndar. Fred was a newsreel cameraman for the Fox Movietone News in 1928, and he filmed the Panay incident, where the U.S. Marines fired upon a Chinese vessel. The resulting furor almost started a war. The Hollywood theatrical film *The Sandpebbles* was based upon the occurence.

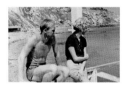

PAGE 70 1937 Dana Point Pier. Pete and Arlene Peterson. Pete was an amazing competitor who gained tremendous notoriety for being able to dominate the tandem surfing event in contests around the world during the fifties and sixties. His mastery of the aquatic arts was so complete that he even had a Scottie dog named Hughie that was the finest surfing dog anyone had ever seen.

PAGE 71 1937 Dana Point. This is a perspective of California's premiere big water spot, taken from the bluff. Later Dana Point was commercially developed in concert with governmental agencies. The effects of this alteration of coastline are still being felt. Extreme shoreline erosion, storm surf property loss, severe pollution, and the virtual disappearance of the local fishing industry are only a few of the results. The point was named after author Richard Henry Dana, who immortalized the place in his book *Two Years Before the Mast*. Interestingly, Dana's documentation of the early California hide trade, makes reference to an adobe-walled structure that is located near the break. This house is the ancestral home of the family of Cecilia Ortega, who was married to Lorrin Harrison. The pioneer surfer and his Spanish landgrant descendant spouse lived together there for many years. Lorrin built canoes and surfboards there

in a old barn where cow hides, which dated back to the time of Dana, still hung undisturbed in the overhead rafters.

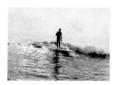

PAGE 72 1938 Dana Point. Bill Bowen. We were down south filming an "Unsung Heroes" motion picture short with Pete Peterson. Pete was out diving for the crew's dinner while we surfed. Before the building of the pier and harbor, Dana Point was a great abalone site. Peterson was an incredible fisherman and no great conservationist. He used to take hundreds of abs a day from San Clemente reef week after week. I'm ashamed now that we didn't know any better, but there wasn't anyone around to tell us not to decimate the lobsters, abalones, and fish except for the Fish and Game Department wardens, and we used to elude them.

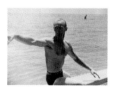

PAGE 73 1937 Dana Point. Pete Petersen. Pete is gesturing toward the inside lineup. Killer Dana was one of the greatest big wave spots on the West Coast. The combined talents of the Army Corps of Engineers and a contingent of Orange County developers reduced this majestic natural wonder into a permanently stagnant pond in just a couple of months. The

Dana name lives on at the boat harbor, but this perversion of commerce bears no resemblance to the incredible original resource.

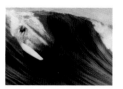

PAGE 74 1939 Hermosa Beach Pier. Jim Bailey. Bailey was considered to be perhaps the top hollow paddleboard surfer on the coast. Only Adie Bayer challenged Jim for supremacy. This picture was taken with a Graflex camera and a 12-inch Royal rectilinear F 11 lens, which I had picked up at a pawn shop. The lens wasn't designed for use with that camera, but after a trip to the sheet metal fabricator we managed to attach the optical monster. It was really sharp since you only shot through the center of the lens.

PAGE 75 Dana Point. Charlie Treago and Pete Petersen. Charlie and Pete are adjusting a waterproof camera housing for a Bell and Howell 35mm motion picture camera. The spar extension was attached to the board to give the camera a stand-off, which provided a unique wave-level perspective. This rig was for one of the "Pete Smith Cavalcade of Sport" film shorts, which starred Petersen.

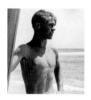

PAGE 76 1938 Malibu. Jack Power. We all wondered what happened to Power. One day he walked down the beach and was never seen nor heard of again. Talk about disappearing into the mists of time.

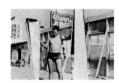

PAGE 77 1938 Hermosa Pier. Jim Bailey with his broken board.

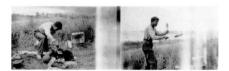

PAGE 78 *top* 1937 San Onofre. Chuck Eddy. Chuck Eddy loved to cook but had the frightening habit of making whatever crawled, flew, or burrowed its way into the campsite into an entree. I was unable to attend school for a week because I had fallen off the back of the bus on which I had hitched a ride and broken my leg. To save the nickel fare I snapped my femur; talk about false economy! We camped for eight days at Onofre and

never saw another soul. The closest resident was Senator Cotton, who lived a couple of miles up the coast in a mansion at San Mateo Point.

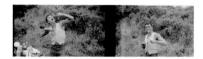

PAGE 78 *bottom* 1937 San Onofre. Fred Beckner. Beckner had immense appetites and no predisposition toward suppressing them. This was brought home to me when Fred would coerce my other "guardians" into leaving me alone in the camp and driving off to the Rendezvous Ballroom in Balboa in the hope of meeting girls. Camp life and its isolation were apparently too much for Freddy, and he would bellow his verbose mating howl and demand transport to civilization. Each time they abandoned me in such a manner, I would wonder if they were ever coming back. They always did, with eight hours being the average duration of their absence. I'm not certain that this was what my mother had in mind when she entrusted her son into their care.

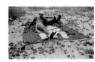

PAGE 79 1937 San Onofre. Chuck Eddy and Fred Beckner.

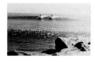

PAGE 80 1938 Long Beach Flood Control. Bill Bowen and Pete Peterson. Bill Bowen became captain of the Santa Monica Lifeguard force after Cap Watkins passed away.

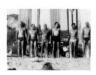

PAGE 81 1938 San Onofre. Pete Peterson, Lorrin "Whitey" Harrison, Adie Baer, (unidentified), and Dexter Woods. These are the winners of the 1938 Pacific Coast Championship.

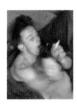

PAGE 82 Dana Point. A San Onofre local and girlfriend. These two were a famous romance of the time. She was a college coed, and he was, for lack of a better term, your basic "surf bum." (It would be years before someone coined that phrase, which described him perfectly.) Here they're both in the bag together atop a bed of balsa wood shavings in Lorrin Harrison's garage. Harrison used to shape boards here for Pacific Systems Homes, a Los Angeles manufacturer of surfing equipment.

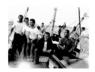

PAGE 83 1939. One and a half hours off Point Dume. Doctor Howard, Bill O'Connor, Frank Donahue, and some other Santa Monica guards on their way to Catalina Island aboard the yacht *Zarak*. Such forays were occasionally disguised as official training missions for the city municipal lifeguard force. During this particular exercise we fortified our esprit de corps at the Avalon Casino Ballroom.

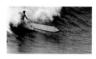

PAGE 84 1939 Venice Pier. Stylish cut-back by an unknown surfer.

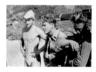

PAGE 85 1939 San Onofre. George Larson, Tommy Gray (who died in the war), and Benny Merrill.

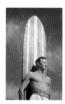

PAGE 86 1937 State Beach, Santa Monica. Chauncey Granstrom. Chauncey's board was a ninety-pound Hawaiian, laminated redwood and pine style, which was popular in the islands at the time. Granstrom was a Pacific Coast Champion in the 1920s, and he served as a Santa Monica lifeguard.

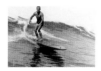

PAGE 87 1937 Paddleboard Cove, Palos Verdes. This Long Beach lifeguard was one of those rare individuals who had completely mastered surfing upon a hollow box paddleboard.

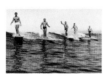

PAGE 88 1937 Palos Verdes. Left to right: Jimmy Reynolds, Tulie Clark, and E. J. Osher. This was the end of their rides and they were still all queued up in perfect alignment.

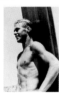

PAGE 89 1937 San Onofre. Jack Power.

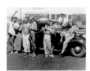

PAGE 90 1939 San Onofre Texaco. Dutchy, Sarah Horner, Jimmy Reynolds, Dexter Woods, Mary Carlson, Bruce Duncan, Lynn Simpson, and E. J. Osher.

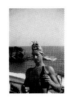

PAGE 91 1941 Laguna Beach. George "Peanuts" Larson. The B Deck helmet of Peanuts Larson was fashioned from the carapace of a lobster.

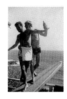

PAGE 92 B Deck, Laguna Beach. Fred Beckner and George "Peanuts" Larson. Tandem master Larson is showing the clan the proper execution of a backside turn. The quart of Balboa brand beer Peanuts is grasping undoubtedly was necessary ballast for this tricky maneuver.

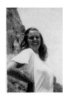

PAGE 93 A girlfriend of mine from USC. On our last date we went to Laguna for the day. Unfortunately, my car broke down, and it took until nightfall to get it going. As we started back, she said that her parents would be pretty upset about her coming home later than they expected. I knew I really was in trouble when the car's headlights suddenly went out.

Wartime blackout conditions were in effect, and it was so dark that there was absolutely no way to drive any farther. We were stuck out there alone on the Old Coast Road, and there wasn't a soul or a telephone around. I let her stay in the car, and I slept outside on the ground. When we finally got to her house the next morning, it was very dramatic. Her parents had called the police and demanded that I be arrested. I never saw her again.

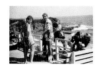

PAGE 94 June 14, 1942 B Deck, Laguna Beach. Convertible Larry, Hugo Walters, and George "Peanuts" Larson. Convertible Larry was a veritable unsolved mystery. On Friday nights he'd arrive at San Onofre driving a LaSalle convertible and wearing a business suit. No one was sure what Larry was involved with back in the city during the week, but his hedonist orientation on the weekends was unparalleled. One day we found out that his car trunk was filled with Leica cameras and Leitz lenses. All of this equipment was sitting in velvet-lined boxes and was worth a fortune. Stuff from the German Leitz factory was rare before the conflict and during the war nobody wanted to be anywhere near it. Larry never was seen taking a picture, and he professed to know nothing about photography. It was a sign of the times that false rumors began to circulate that Convertible Larry was a Nazi spy.

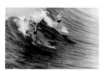

PAGE 95 1940 Venice Pier. Jack Fuller and Pete Peterson. Peterson built surfboards, which he sold shaped for the price of thirty-five dollars. Units sanded and coated with five coats of Val Spar Marine Varnish went for ten dollars more. Here Pete is seen letting Fuller test ride his personal board at the old Venice Pier. Pete liked to drop his girl off at the tile factory in Malibu and then surf the break all day. At five o'clock he would paddle back in and chauffeur his lovely girlfriend back home.

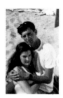

PAGE 96 1940 Sorrento Beach. Bob Gregory and girlfriend.

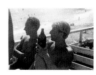

PAGE 97 1942 B Deck, Laguna Beach. Brant Goldsworthy and Peanuts Larson. B Deck was Larson's name for a house he rented in the cove immediately south of Emerald Bay. Brant Goldsworthy was a pioneer of plastic technology. He invented a number of polymers and some of his formulations are still in common use today. He helped Pete Petersen to build a fiberglass hollow board in 1947. It was the first all-fiberglass surfboard.

PAGE 98 1940 Santa Monica Pier. Frank Donahue, Bill Bridgeman, Hugo Walters, Dan Ranier, and Bill O'Conner with the Chevy convertible.

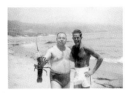

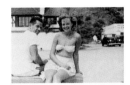

PAGE 99 Tony Galento and Don James. Tony was a well-known professional wrestler of the time, and we really had a hard time persuading him to hold this lobster for the photo. It's funny how different people have different fears… Here's this big, tough guy who's terrified of a little lobster, while I would never for a second think of climbing in the ring. My friend Bill Bridgeman was a test pilot who held the world speed record and routinely shattered the sound barrier, but he would refuse to dive down to pick up a lobster.

PAGE 101 1939 Sorrento Beach. Before she became a famous actress, June Lockhardt was just another beachgoer. This photo documents our brief affair. It lasted approximately 1/125th of a second, just long enough for a friend to snap this picture. Norma Shearer's home can be seen in the background.

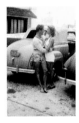

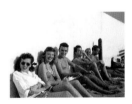

PAGE 102 1941 Santa Monica Pier. Willy and Dianne Moore. Willy was a lifeguard and a diver.

PAGE 100 1939 Sorrento beach. Right to left: Bryce Fuller, Norman Lyons, Don James, Al Deans, Donna Powell, and Gina Rose. Sorrento was located in Santa Monica at the base of the California Incline road. A couple of decades later I would live just up the beach next door to fellow surfer Peter Lawford. Our idyllic life would be destroyed whenever Peter's brother-in-law, John F. Kennedy, would come to visit. JFK delighted in going for a swim in the surf, ditching his secret service guards in the process, and then resting against this very same wall while watching the melee as they frantically searched for him.

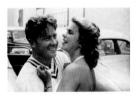

PAGE 103 1941 Santa Monica Pier. Willy and Dianne Moore.

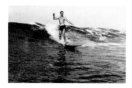

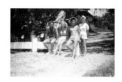

PAGE 104 1938 Palos Verdes. Jack Power.

PAGE 107 1943 Oak Street, Laguna Beach. I was in dental school, tooling around in Frank Donahue's old '40 Chevy convertible. Girls were everywhere during the war years, and we all felt a little guilty having so much fun with the fighting going on. My time in the navy came later – in '44, I remember swimming at Okinawa in an area I thought was secured. I knew that we were still mopping up elsewhere on the island, but the ocean looked so inviting that I just had to jump in. I was offshore diving on a sunken Japanese ship when the water started splashing all around me. The air buzzed and I realized that a sniper was zeroing in on me. I hid behind a rock and waited several hours for nightfall so I could skulk back in. During those long hours I recalled the guilt we had all shared that day in Laguna. I would have gladly traded places with that worried aspiring young dentist back at Oak Street. I no longer felt guilty; right then I felt stupid and lucky.

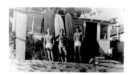

PAGE 105 December 7, 1941, Topanga Point. Ed Fearon, Don James, and Jack Quigg. It was a balmy Sunday and the news about the Japanese attack upon Pearl Harbor was coming in over the radio. We were paying sixty dollars a month for rent, which was split three ways, and life was good. Suddenly everything had changed. We all knew we were going off to war.

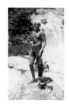

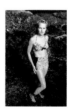

PAGE 106 1942 Coast Inn, Laguna Beach. Hugo Walters and catch. In the early fifties, Hugo, Paul Stater and a guy named Sears were about three quarters of the way to Catalina when Paul's boat went down. Stater swam for fourteen hours and eventually reached the island, but Walters and Sears disappeared forever.

PAGE 108 1942 Scottsman's Cove, Laguna Beach. Myra Roche. I had envisioned this photo of Myra for a while. I borrowed a Leica A III camera to shoot it with because I wanted that sharp Leitz lens look. When I first did it people responded to her naturalness. It still holds up in my estimation.

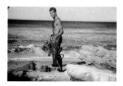

PAGE 109 1942 Point Dume. Don James with some big lobsters.

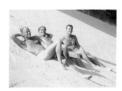

PAGE 110 1942 Point Dume. Bill Bridgeman, Hugo Walters, and Frank Donahue. This Mack Sennett bathing beauties parody has caused three decades of surfing magazine editors to recoil in disgust. No one has yet dared to publish it; I guess it's a sign of the changing times. Bridgeman later appeared on the cover of *Time* magazine in 1951 after he piloted the X-3. Bill augered into the Pacific in twenty-five hundred feet of water while flying an amphibious shuttle plane to Catalina. Because he was such a superb pilot, people thought that he had suffered a heart attack or a stroke. His wife Jackie wrote a book about his adventures called *The Lonely Sky.*

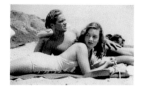

PAGE 111 1942. San Onofre. Hugo Walters and Ann Green.

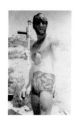

PAGE 112 1942 Trafalger Street. George "Peanuts" Larson. Peanuts was a rogue individual who you were never quite sure about. Here he can be witnessed in his full glory after a month of sleeping on the beach at San Clemente reef without a bath. Larson didn't sweat the amenities; he lived entirely off the sea. He would have made an ultimate jungle fighter or underwater demolition team member, had he made it to the war. Ironically, Peanuts instead chose to spend the night before his pre-induction physical in a closet, where he continually lit sulphur matches in the hope that their fumes would bring on a severe asthma attack. His plan worked, and they gave him an immediate 4-F classification.

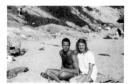

PAGE 113 1943 Coast Inn, Laguna Beach. Don James and Ann Newell. During World War II, San Onofre was taken over by the military and declared off-limits to civilians. We began to frequent the Laguna area since the diving was great. I graduated from dental school a year later and went into the navy.

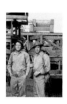

PAGE 114 1942 Culver City. Frank Donahue and Don James. Donahue always had something going. During college, Frank realized that the movie studios needed young men to populate the spate of war films they were producing. This was taken on the set of *Back to Bataan,* which featured John Wayne. The money was great, with the pay scale starting at thirty-five dollars per day. With stunt adjustments, you could clear up to a hundred bucks.

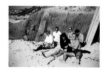

PAGE 115 1942 La Jolla Cove. Nancy Lorie, Don James, Rachel Brown, Frank Donovan, Elizabeth Henry, and Mark Wusig. I was an apprentice seaman in dental school at the time. That weekend, to impress the girls, Donahue decided to organize a tour of the submarine he was serving on. At first it didn't seem like such a great idea, but as I recall by the third pitcher of martinis, it was sheer genius. Frank procured a laundry bag full of uniforms somehow, and we all snuck on the base wearing them. The actual tour of the sub was uneventful, but since Donahue had disguised me in an officer's uniform, everywhere we went sailors saluted me. When Frank started the engines, all hell broke loose and the sub's security detachment arrived with their weapons drawn. Somehow they bought my Lieutenant JG-bit and then pretended not to notice that our ordinary seamen weren't really men at all. Donahue's bravado was unparalleled. In succeeding years, Frank would roll through one amazing adventure after another. Probably his

greatest legitimate escapade was capturing and "fresh-water training" live sharks for Howard Hughes's RKO movie studio. Donahue would go out and catch the sharks at dawn, come ashore and load them into a trailer, and then haul them up to Hollywood in time for the day's shoot.

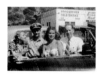

PAGE 116 1943 Sorrento Beach Grill. Eva Proctor, Bob Stein, Laura Hunt, and Don James, Sr.

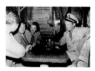

PAGE 117 1943 The Galley Cafe, Santa Monica Pier. Fred Bleeker, Bill Moore, Donna Chilton, Ray Hutchinson, Frank Donahue, and Don James. Another night of mid-war merriment. Blackout curtains shielded the restaurant from the eyes of the world. Only the patriotic zeal of the local boys and girls stood between us and them. It was up to red-blooded zealots such as those ever-vigilant types seen in this photograph to save the nation.

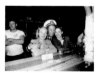

PAGE 118 1943 The Galley Cafe, Santa Monica Pier. Bill O'Connor, Rosemary, Don James, and Rita Florence. The times had a desperate air. Anything went in a nervous laissez-faire sort of way.

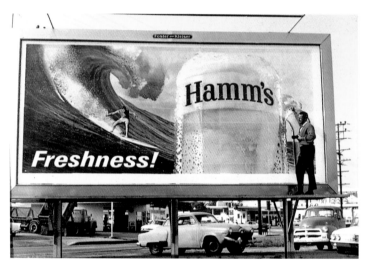

1963. Dr. Don James with billboard featuring his famous Sunset Beach photo.